BELLPORT REVISITED

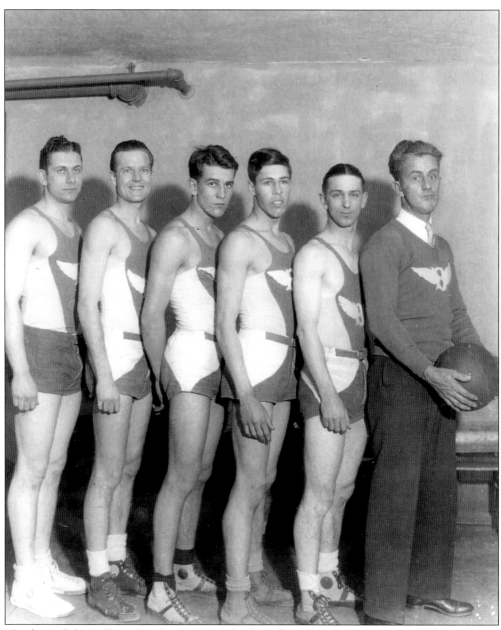

Members of the Bellport Fire Department's basketball team pose for a picture in the winter of 1932 with their coach, Forrest Bumstead. Bumstead was the son-in-law of Everett Price, Bellport's first mayor and fire chief. He lived at 49 Station Road. Team members from left to right are Phil Weissonaur, ? Demarest, Willis Hawkins, Wilbur Corwin, and Billy Newham. (Courtesy Forrest Meachen.)

On the cover: The Bellport Classical Institute, or as it is commonly known, the academy, has been a school, a place of worship, a carpentry shop, and finally a home. It has been moved twice on the same street that now bears its common name. It is a Bellport icon and is on the National Register of Historic Places. This picture shows the academy in its original use as a school from 1833 to 1901. (Courtesy Bellport-Brookhaven Historical Society.)

IMAGES
of America

BELLPORT REVISITED

Victor Principe

ARCADIA
PUBLISHING

Published by Arcadia Publishing
Charleston SC, Chicago IL, Portsmouth NH, San Francisco CA

Printed in the United States of America

Library of Congress Catalog Card Number: 2007938167

For all general information contact Arcadia Publishing at:
Telephone 843-853-2070
Fax 843-853-0044
E-mail sales@arcadiapublishing.com
For customer service and orders:
Toll-Free 1-888-313-2665

Visit us on the Internet at www.arcadiapublishing.com

To Carol Bleser, for many reasons

CONTENTS

ACKNOWLEDGMENTS

I am indebted to many who have been so generous to me with their time and knowledge. First and foremost, I would like to thank David McChesney for his technical support. He spent many hours scanning almost a third of the photographs. Without his help and patience, many of the images could not have been included in the book. I am immensely grateful to Dr. Carol Bleser, whose enthusiasm and encouragement for this project was immeasurable. She was always ready to give helpful advice. I thank the Bellport-Brookhaven Historical Society for allowing me to use their archives once again; without their cooperation this second volume would not have been possible. I appreciate the assistance of Robert Duckworth, who enabled me to fill in some gaps with his contemporary photographs. I am most grateful to Anne Swezey for her kind and enlightening recommendations. I am thankful to Mark Rothenberg, historian at the Patchogue-Medford Library, who was so accommodating and provided me with invaluable resources when researching East Patchogue. Peter Berman and Marjorie Roe at the Greater Patchogue Historical Society graciously provided useful information. I am grateful to Barbara Russell, historian for the town of Brookhaven, and Nan Bunce, librarian at the South Country Library. I appreciate the insight into the world of yachting provided to me by John Everitt and Hank Maust. I want to express my deep appreciation and thanks to the following, who shared their reminiscences or photographs with me and without whom the book would not have been possible: Barbara Avery, Peter and Tilly Austin, William Bianchi, Judith Bianco, Peter Berman, Dufy Brown, Ronald Bush, Emily Czaja, Robert Duckworth, John Everitt, Radey Johnson, Gray Lyman, Dorothy Maggio, Forrest Meachen, Julia Paige, Jane Platt, Allen Sakaris, Michael Siems, Jean Steele, Priscilla Swezey Knapp, Anna Terwilliger, Patricia Trainor, and John and Janet Vander Zalm. In addition, I want to thank Eric Bowman and Peter Schlesinger for the tour of their home. I also want to thank the team of Keif Roberts and Donald Pruden Jr. at Left Turn Productions for recording the oral histories. I am grateful to Bruce Wallace and Tom Williamson at the Post Morrow Foundation for their help on the peat hole. A window to Bellport's past was provided by the *Brooklyn Eagle* and the *Patchogue Advance*. Four people, Dr. Carol Bleser, Alun Davies, Dr. Ira Hayes, and Dr. John Renninger, read the manuscript in its entirety and this book is the beneficiary of their insightful recommendations. Lastly, I thank my partner, John Renninger, for his constant and steadfast support.

Victor Principe
Bellport, New York
2007

INTRODUCTION

In the late 19th century, Jennie J. Young wrote a tongue-in-cheek description of Patchogue Station for a visitors' guide to Long Island titled *New Long Island: A Hand Book of Summer Travel*. For those traveling further east to Bellport, she reported that "no mirage was ever more deceitful than was Patchogue Station to what lies beyond." Patchogue Station was the terminus of the Montauk line until 1881, and visitors changed to coaches or taxis there to continue their journey east. Since Bellport was an established summer resort only three miles away but not well known to many, she went on to reveal its glories and the glories of the area just west of it and to demolish the absurd opinion "that there was nothing beyond Patchogue but a sandy barren desert, left unfinished by the Creator and abhorred of Man." In a complementary vein some years later after the Montauk line was extended east, the *Brooklyn Eagle*, remarking on the infrequent train service to Bellport, came to the conclusion that the Long Island Rail Road considered everything east of Patchogue the country and out of commuting range, therefore making frequent service unnecessary.

The Bellport of the 19th century survived the 20th century to be enjoyed in the 21st century through the commitment and determination of a succession of its residents. In the early 1920s, when New York State planned to run Montauk Highway through the village of Bellport, the tireless efforts of Birdsall Otis Edey, president and founder of the Village Improvement Society, prevented it. She convinced the state to have the highway pass half a mile to the north of Bellport, thus setting the stage for slow growth and preventing commercial sprawl in adjacent East Patchogue and Brookhaven Hamlet. The result was that Bellport's downtown remained neatly demarcated. Another resident, Stephanie Bigelow, led a 10-year effort that succeeded in placing 80 Bellport houses on the National Register of Historic Places on July 4, 1980. At the start of the 21st century, the Village Board of Trustees, under the leadership of Mayor Frank Trotta, established the Bellport Historic Preservation Commission and gave it the power to designate and preserve historic districts and historic landmarks.

The instances above suggest that the ambience of Bellport Village is not just a product of its propitious location on the Great South Bay and its beautiful historic homes. After all, there are several villages on the south shore of Long Island that are on the water and have lovely old homes. The critical factor that many other villages have lost but that the Bellport area retains—because of luck, relative isolation, and especially determined citizens—is a strong sense of place. This sense of place was conserved by development that has been, on the whole, kind to both its residential and commercial character. It is this defining quality that makes the area such a desirable place to live. Bellport has been the beneficiary of creative thinkers

and serendipitous circumstance and blessed by a critical mass of architecture that combines a refreshing mix of age, character, and scale.

As the village of Bellport celebrates its 100th anniversary of incorporation in 2008, the lesson that Bellport imparts is timeless. Historic preservation makes for good living. It can also affect one's sense of well being as well as one's sense of happiness. The author's royalties generated by this second volume on the Bellport area go to support the Bellport-Brookhaven Historical Society in its efforts to preserve and promote the historical heritage of Bellport, Brookhaven, and East Patchogue. This book complements the first volume, *Bellport Village and Brookhaven Hamlet*.

One

ON AND OFF
MAIN STREET

Bellport Village's commercial center is visually simple. Main Street consists mostly of one, two, and two-and-a-half-story frame structures, some with peaked roofs and some with flat roofs. Many buildings are shingled or painted. Through the years, all the buildings in the commercial district have undergone change, but Bellport is fortunate in that the changes have not been fatally disruptive to Main Street's textural fabric.

The most prominent building on Main Street is the red painted former Howell's General Store. It sits at one of the four corners, the center of downtown formed from the intersection of South Country Road, Station Road, and Bellport Lane. Diagonally opposite at the southwest corner is the recently reshingled Hulse General Store, now the Bellport Deli, and further west, the house of Catherine Osborn, which is today the Old Inlet Inn. At the northeastern end of Main Street is the firehouse; at the southeastern end is Brown's Garage. In between, an old theater houses a supermarket called Wallen's that serves a fiercely loyal clientele, and a mix of pleasant, unpretentious little buildings are occupied by various retail establishments. The three-story Bellport Hotel on Bellport Lane is today an apartment house but still has a bar as it did when it opened in 1898.

Both east and west of the commercial center on South Country Road stand many old Bellport houses, but some of the largest and most stately on the north side of the street west of the four corners—namely the Osborn, Titus, McLean, and Bieslen houses—have been torn down, as have Old Kentuck and the Hoyt-Phillips house at the southeast edge of the village and the Locusts estate to the southwest. When the Locusts and part of Woodacres, the Lyman family farm next door in East Patchogue, were combined in 1917 to form the new golf course, both houses survived, and the residence at the Locusts became the clubhouse. In 1954, however, it was displaced with the mundane.

Historically and architecturally important buildings surrounding Main Street have been irreparably lost, especially the Bell and Osborn houses near the four corners and Eva Smith's house on Woodruff Street. However, Bellport has so far managed to retain its essential character. What remains is beautiful, and what has been added is, for the most part, appropriate to the setting.

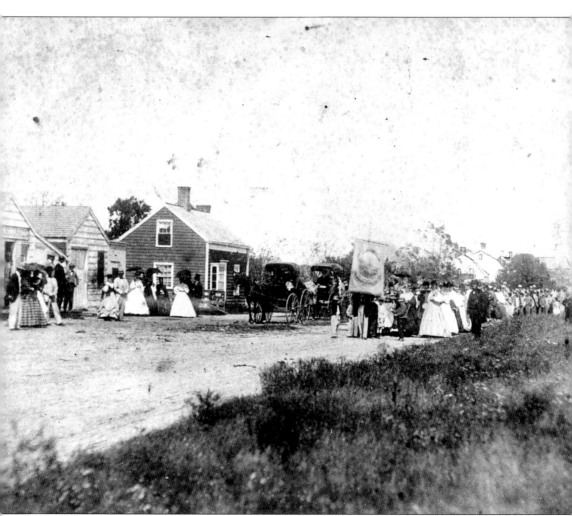

The earliest depiction of Main Street in Bellport shows the Presbyterian Sunday school parade in 1868. The perspective is northeast. In the far distance to the right, 167 South Country Road, belonging to Andrew Homan and later to Donald Shaw, is visible. Also seen are 173 South Country Road, owned by James Watkins; the chimneys on Oliver Hazard Perry Robinson's home, which was moved to 33 Browns Lane around 1918; and the Presbyterian (now Methodist) church with its white picket fence. The house in the left center was the birthplace of Charles H. Hawkins and became part of an old house at 27 Station Road. It sits about where Angelo De Santis later had his second cobbler shop at 145 South Country Road in the early 20th century. The two buildings to its left belonged to Capt. James Hulse. One of them was a barbershop. (Courtesy Bellport-Brookhaven Historical Society.)

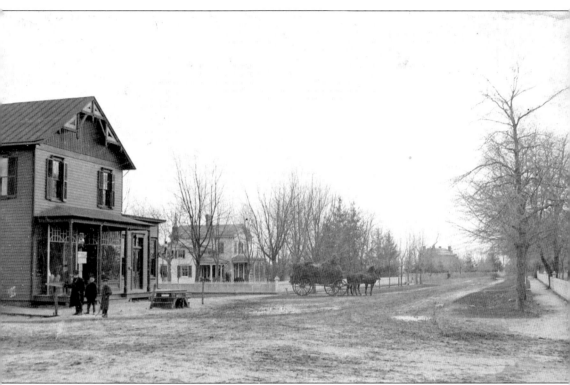

A western perspective from the four corners is seen here at about the end of the 19th century. Capt. Simeon Hulse and his brother Jim operated the store on the left in the last quarter of the 19th century. The little wing on the right side of the building was added around 1894 as a post office. This was the first post office in Bellport; before this addition was constructed, it was customary for the post office to be in the home of the postmaster. West of the Hulse store is the house where Catherine Gerard Osborn lived during her widowhood. Today it is the Old Inlet Inn. Across the street is the fence that enclosed the Edward Osborn property that was demolished in 1958. In the distance on the left is the house built by Henry Weeks Titus around 1835 that became the summer residence of Birdsall Otis Edey and her husband, Frederick, in 1865. (Courtesy Bellport-Brookhaven Historical Society.)

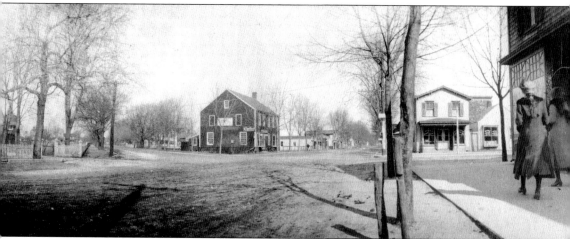

This picture was taken in 1913. Osborn Shaw, Brookhaven's town historian from 1930 to 1959, described this scene as the "Four Corners, Bellport." The perspective is east, down an unpaved Main Street in winter. "The business center of the village is a mile and a half from the water, snugly placed along one or two well-shaded streets," the *Brooklyn Eagle* described two decades earlier. "Neat shops and stores which sell a great variety of things all together, are numerous. There is a general air of thrift and quiet which is refreshing after the heat and noise of the city." Seen on the southeast corner is Will Gardiner's real estate office. Gardiner built the Bellport Hotel and 138 South Country Road, which is today occupied by the Variety Mart. East of the Howell's General Store (center) is a fenced lot that was soon occupied by the Comet Theatre and eventually became Wallen's Supermarket. Behind the fence in the left foreground is the caretaker's house for the Osborn property that today is a commercial garage behind 19 Station Road. (Courtesy Bellport-Brookhaven Historical Society.)

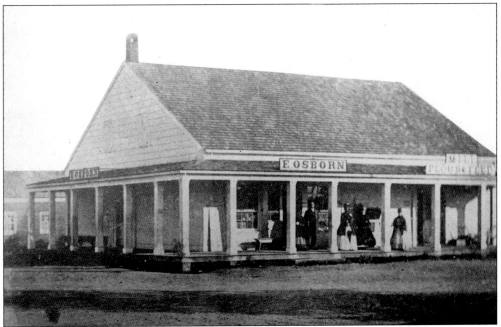

An undated photograph shows the 1836 general store owned by Edward Osborn. It was at the southwest corner of the four corners and was later moved to become part of the Wyandotte Garage. The Hulse general store replaced it. (Bellport-Brookhaven Historical Society.)

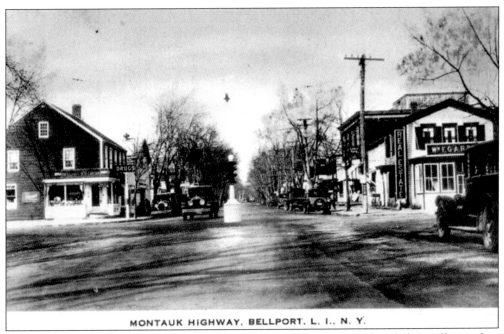

MONTAUK HIGHWAY. BELLPORT. L. I., N. Y.

By the early 1920s, the four corners had a traffic stanchion that replaced the traffic warden, which was eventually replaced by a traffic light. This postcard shows the four corners with the stanchion. The view is east, and the Lucas Pharmacy is at the base of the Howells General Store on the left. (Courtesy Bellport-Brookhaven Historical Society.)

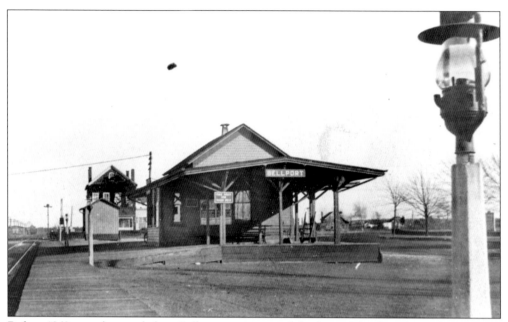

Before 1869, people traveled to Bellport on trains of the Long Island Rail Road's northerly Greenport line. Travel became more convenient when the southerly Montauk line opened that year, reaching Patchogue. Until 1881, before Bellport had its own station, travelers went to Patchogue and took a coach to Bellport. Bellport's train station is shown above around 1920. (Courtesy Bellport-Brookhaven Historical Society.)

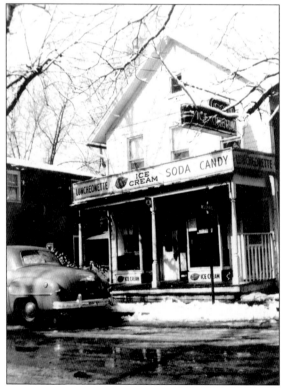

This undated picture shows 159 South Country Road. The Coleman family owned the luncheonette in the 1940s, followed by the Raddatz family. In the 1980s, it was a restaurant called the Bellport Kitchen. Its owners added porches to the building that came from a New York restaurant. Today the Bellport, a restaurant, occupies the space. (Courtesy Patricia Trainor.)

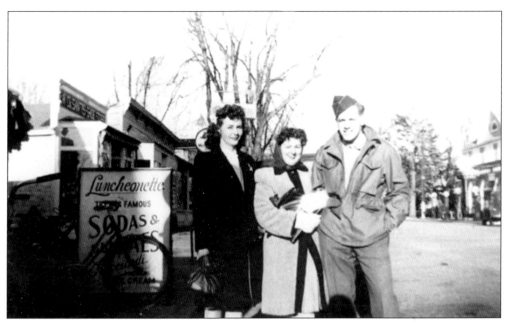

These Bellporters are standing in front of the Hawkins Store in November 1944 near the end of World War II. From left to right are Virginia Valentine, Emily Czaja, and Marion "Mort" Czaja. Marion was on leave from the air force. The group is facing west, and the Browns Garage building can be seen in the background. (Courtesy Emily Czaja.)

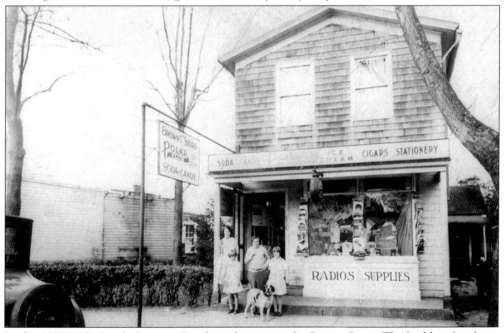

In the 1920s, 153 South Country Road was known as the Brown Store. The building has been added to since. This picture was taken on December 21, 1928, and shows, from left to right, Ella Brown and Marie Murdock with Emma and Gladys and their dog Spot. Today Eileen Green Realty and Intrigue Hair Salon occupy the enlarged building. (Courtesy Bellport-Brookhaven Historical Society.)

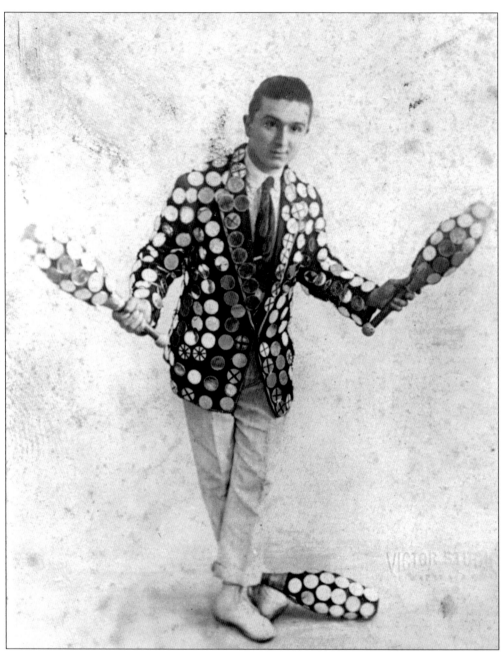

Pictured is Henry Ferrier, a man who knew how to entertain Bellporters. He came upon Bellport while serving at Camp Upton (today's Brookhaven National Laboratory) during World War I and met his future wife, Helen Read, at the American Red Cross dance for soldiers that was held at 146–148 South Country Road (today's Brookhaven Country Florist and Trotta's Vacation Store). He settled in Bellport in 1923 after having worked as a juggler with the Keith Circuit, traveling with fellow vaudeville artists, including W. C. Fields, Sophie Tucker, and Irving Berlin. Ferrier designed the mirrored jacket he is wearing and decorated his clubs with the same small, round mirrors. In Bellport, he worked for Armstrong and Pierman as a painter and decorator and juggled on the side. (Courtesy Anna Terwilliger.)

Railroad Avenue (Station Road) has been the main access to the center of Bellport Village from the north since it was laid out around 1851. By 1900, most of the land on both sides of the road was owned by Charles Osborn. Woodland Cemetery (1876), Bellport High School (originally built in 1929), Ruth African Methodist Episcopal Zion Church (1827), and South Country Library (1986) all occupy former Osborn land. (Courtesy Bellport-Brookhaven Historical Society.)

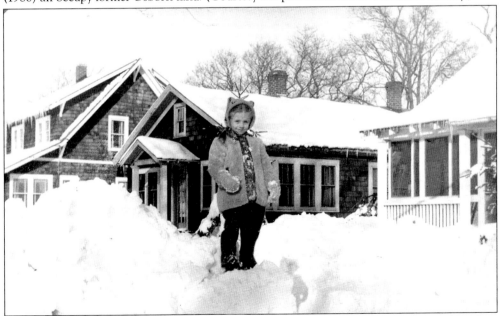

Posing in the snow dumped on Bellport in the blizzard of 1948 is Forrest Bumstead's granddaughter Linda Meachen. She is standing in front of his home at 49 Station Road, a home typical of the type that was built along that road in the early 20th century. Behind her is 51 Station Road, unrecognizable today, and just north of it is 53 Station Road, home of the Grucci fireworks family. (Courtesy Forrest Meachen.)

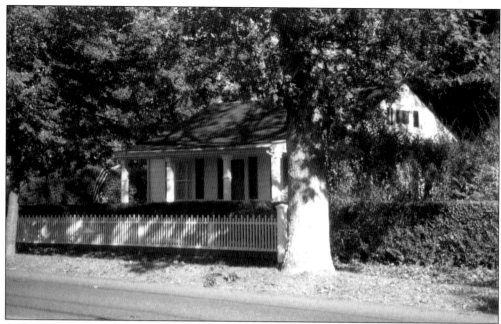

Built around 1920, 85 Station Road is a distinctive Greek Revival–style bungalow. While most homes on Station Road were built between the two world wars, there are a few older ones near the four corners, some altered beyond recognition. A 19th-century barn also sits behind Lyons Fuel Company at 23 Station Road. (Courtesy Robert Duckworth.)

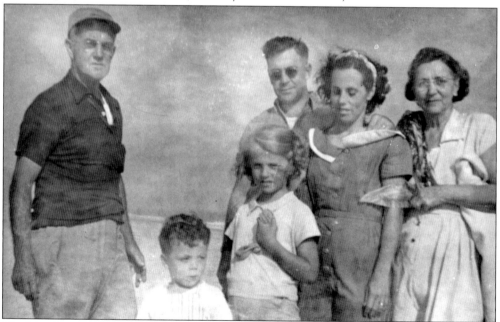

The Meachen family lived on Fourth Street east of the Bumsteads' and not far from Mott's Hill, which was a place popular for winter sleigh riding. This photograph from about 1950 shows, from left to right, Forrest Bumstead, his grandchildren Forrest and Linda Meachen, James Meachen and his wife, Isabelle Bumstead Meachen, and Maude Price Bumstead. (Courtesy Forrest Meachen.)

The north boundary of Bellport Village is Head of the Neck Road. East of where it intersects Station Road and near New Jersey Avenue was the 13-acre farm started by Ari Vander Zalm in 1954. Here is Vander Zalm's son John with crates of freshly picked strawberries. Behind him is Wards Lane, where the Bellport Laundry was located. (Courtesy John and Janet Vander Zalm.)

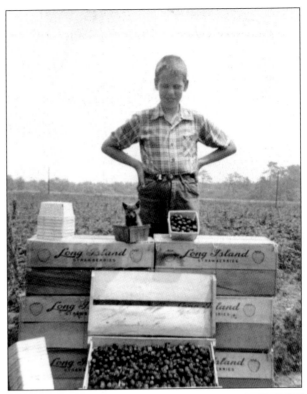

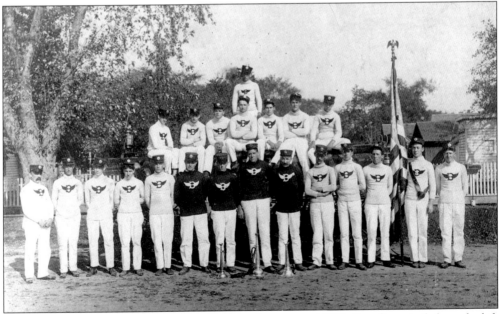

The Bellport Hook and Ladder Company is seen here around 1893. Standing ninth from the left in the front row is Bellport's first mayor and fire chief, Everett Price. The firemen are on South Country Road about where Bellport's first firehouse was constructed. In front of the men are three silver Brooklyn Eagle Trumpets, prizes for winning contests known as hook and ladder races with other fire departments. (Courtesy Bellport-Brookhaven Historical Society.)

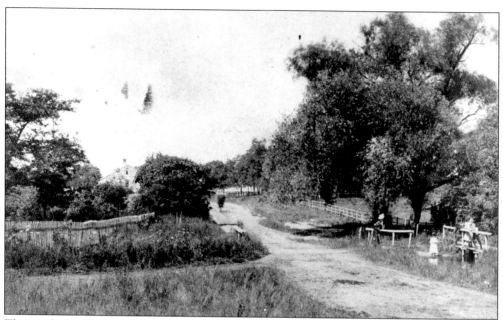

The creek that defines the eastern boundary of Bellport Village was originally called Dayton Brook, later it was known as Osborn's Brook, and, finally, as Mott's Brook and Langley's Creek. This undated photograph shows South Country Road facing east. The figures to the right are on a little footbridge over the creek. On the left horizon is 231 South Country Road. (Courtesy Bellport-Brookhaven Historical Society.)

This undated photograph shows Mary Williamsen and her daughter in front of their cottage on the estate of Maj. William H. Langley, called Old Kentuck. Mary's husband, Charles, worked for Langley. The cottage, now enlarged, still stands at the end of Brookside Avenue. Other surviving structures from Old Kentuck, now private homes, are the stable at the end of Wigtel Lane and the gardener's cottage near it. (Courtesy Dorothy Maggio.)

The children of Charles Williamsen, Tom and Dorothy, with their dog Bridget are standing on the shore of Old Kentuck next to the boathouse in this undated photograph. Behind them to the east is the dock of the Hoyt-Phillips estate. Today's Mooring Drive is located where the Hoyt-Phillips property once stood. (Courtesy Dorothy Maggio.)

Dorothy Williamsen is hugging Bridget on the running board of Langley's automobile in this 1916 photograph. In the background is the coach house for the estate. Langley was very generous to his employees and their children; he made it possible for Charles Williamsen's son to attend Notre Dame and for his daughter to go to finishing school. (Courtesy Dorothy Maggio.)

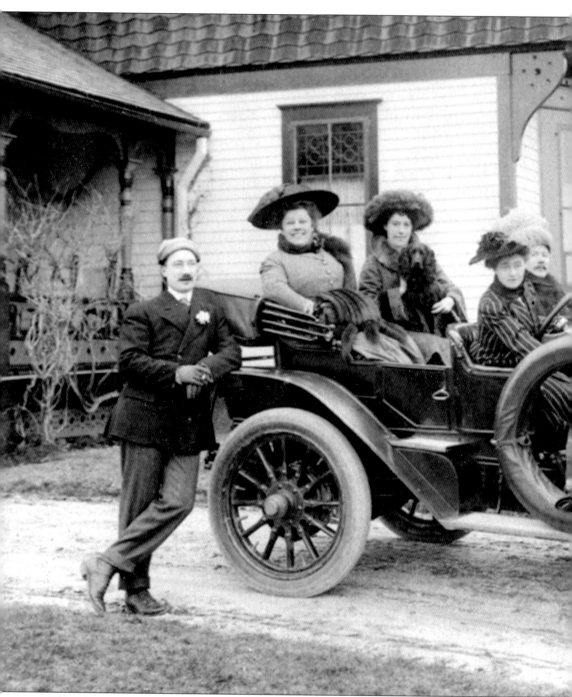

This photograph from about 1915 shows Maj. William H. Langley leaning on his automobile at his estate, Old Kentuck, which was built by William Fosdick in the previous century. The women are identified as "show ladies from New York City." Charles Williamsen, Langley's chauffeur and captain, is in the driver's seat. Leaning on the left is Pop Barton, his secretary. A glowing description of the property by the *Brooklyn Eagle* in 1890 described the mansion as "light, graceful" and in harmony with its surroundings. It went on to declare that "the idea of

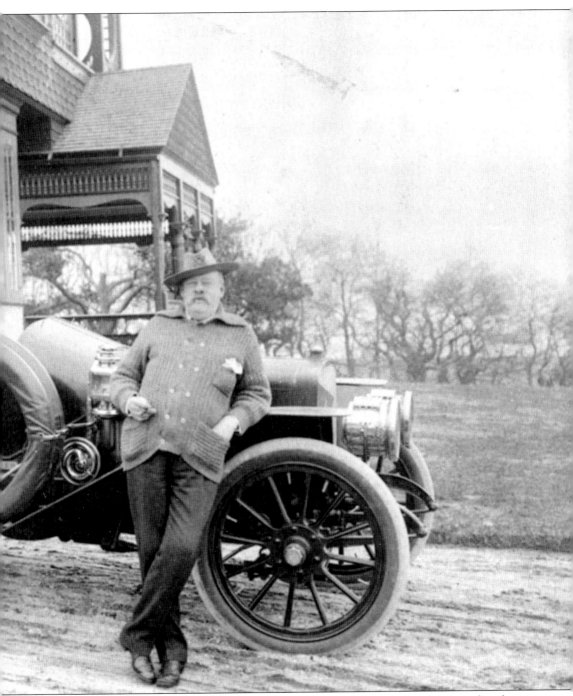

conforming the architecture of a residence to the environment is not new by any means, but those who possess the good taste to judge properly in these matters are rare, and still more uncommon are those who will follow the advice of intelligent artists." Old Kentuck had a distinctive water tower and was across the road from Lucy Mott's summer home. It was torn down after World War II for the Bay Harbor housing development. (Courtesy Dorothy Maggio.)

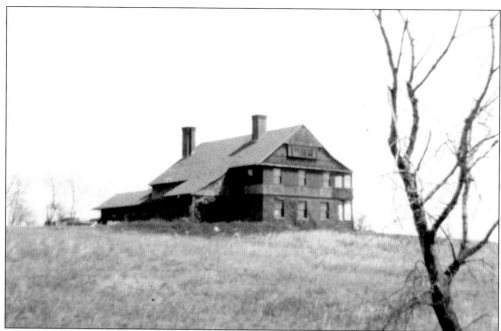

The Hoyt-Phillips house stood on high ground east of Langley's creek and west of the Cook estate off Bellhaven Road, where Douglas Fairbanks Sr. often visited in the 1920s. To its immediate northeast on the same side of the road was a small fisherman's cottage that almost certainly predated all the estates in the area. This little house (pictured in the first volume) still stands at 234 South Country Road. (Courtesy Bellport-Brookhaven Historical Society.)

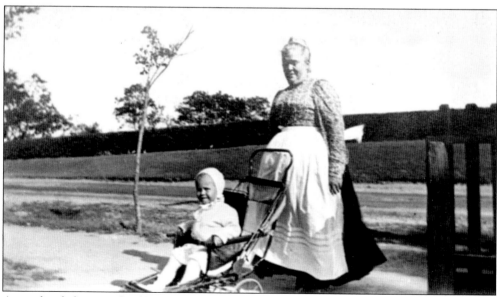

An undated photograph of James Hoyt Phillips with his nanny was taken on a windy day at the north edge of the property. The background is still recognizable. (Courtesy Bellport-Brookhaven Historical Society.)

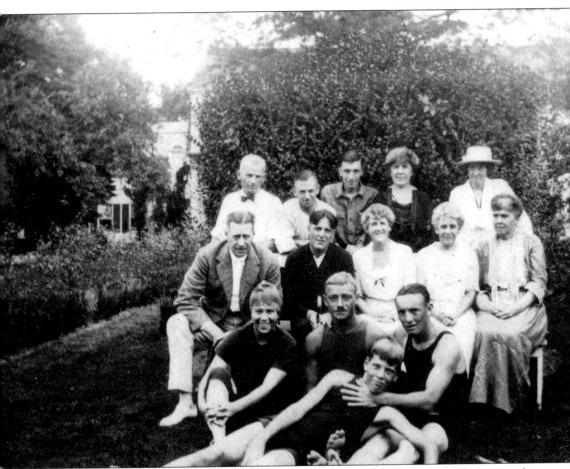

Across the road from the Hoyt-Phillips and Langley properties was Brook Farm, the estate of Lucy Mott, known today as the Gateway. Mott purchased her residence, built by Charles Osborn in 1827, from Ira B. Terry in 1884. Mott was a benefactor of Bellport, donating land that was formerly part of Capt. Thomas Bell's apple orchard on Bellport Lane for Bellport's first library and community center, partially financing both. In her widowhood, Mott took an interest in the welfare of disabled veterans. Visiting receiving hospitals in New York after World War I, she invited disabled ambulatory men to recuperate at Brook Farm. Mott installed a pool and built a cottage on her property for these men. She named it Effervescent Cottage because, as she was quoted in a local newspaper, "the boys always seem so full of fun and spirit there." This undated photograph was taken at Brook Farm after World War I. Mott is seated at the far right in the second row; around her are unidentified friends and guest veterans. (Courtesy Jean Steele.)

The George Breckinridge family of Brookhaven Hamlet was photographed on October 3, 1897. George was the brother of Isabella A. Bumstead, Lillian Forrest Reeves, and Mary Elizabeth Smith. Forrest Reeves worked at the Brook Store in Brookhaven Hamlet. (Courtesy Bellport-Brookhaven Historical Society.)

Seated in the rocking chair with his grandson Winfred on his lap in this 1915 photograph is Adison Bumstead, the father of Forrest Bumstead. Forrest married the daughter of Everett Price, Bellport's first mayor. (Courtesy Bellport-Brookhaven Historical Society.)

This undated picture shows Capt. Dod Munsell's home at 21 South Country Road at the time when Francis A. Otis's estate, the Locusts, was across the road. The Locusts is the site of the present-day Bellport Country Club, originally called the Links at Bellport and then the Suffolk Golf Course. (Courtesy Bellport-Brookhaven Historical Society.)

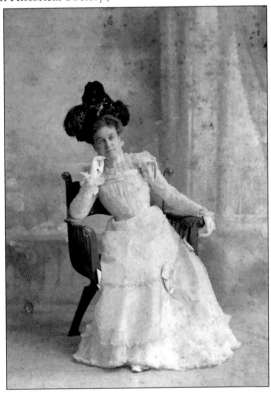

Urania Gerard Shaw, daughter of Joseph Meritt Shaw and Caroline Amanda Gerard, married Dr. Charles Wilber Walling in an evening ceremony at Christ Episcopal Church. They were the first couple married at the new church, built in 1896. (Courtesy Bellport-Brookhaven Historical Society.)

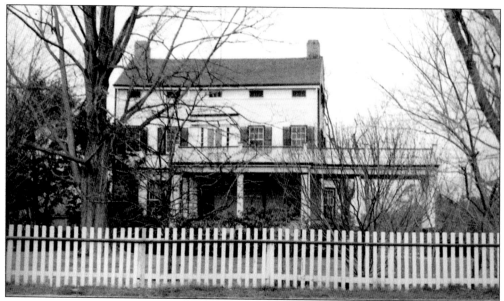

Pictured here in 1955 is 89 South Country Road, which was built for Orlando Bennett around 1858. Bennett was sent to the area to wreck the *Irene*. He met and married Amelia Bell, Capt. John Bell's daughter. They had one daughter, Irene. Phillip Hurbert purchased the house in the 1890s and added a new first floor without bothering to remove the old front door. It remained on the second floor until very recently. The house was called Villa Messina in the 1980s. (Courtesy Bellport-Brookhaven Historical Society.)

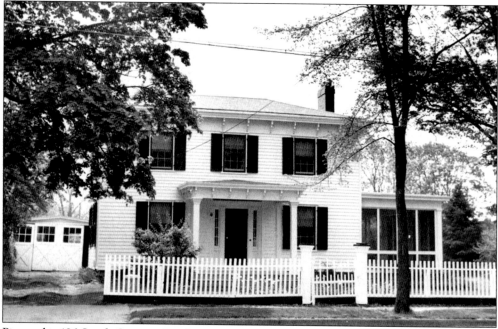

Pictured is 186 South Country Road in 1955, a Greek Revival house built by Charles Silas Platt around 1857 and later owned by his granddaughter Katherine Goldthwaite Tilden. It stands next door to Temperance Hall on land purchased by Platt from Capt. Thomas Bell. (Courtesy Bellport-Brookhaven Historical Society.)

Kate Gerard Platt was one of the daughters of Charles and Urania Gerard Platt and was born at 186 South Country Road. She married Henry W. T. Post. (Courtesy Bellport-Brookhaven Historical Society.)

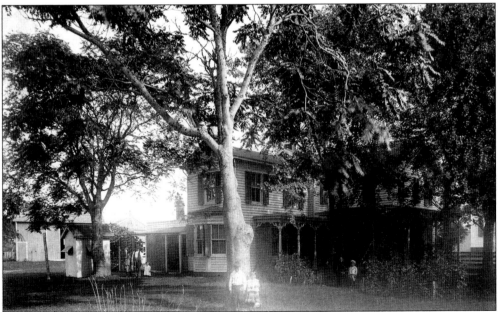

This home at 181 South Country Road was built in the 1870s for the Henry F. Osborn family by James Watkins, who, by the beginning of the 20th century, owned most of the land east of New Jersey Avenue north of South Country Road. This picture, taken in the 1890s, shows Eliza Osborn, some visiting children, and Pat Reilly near the milk house. The barn behind the milk house is now a separate home on First Street. (Courtesy Bellport-Brookhaven Historical Society.)

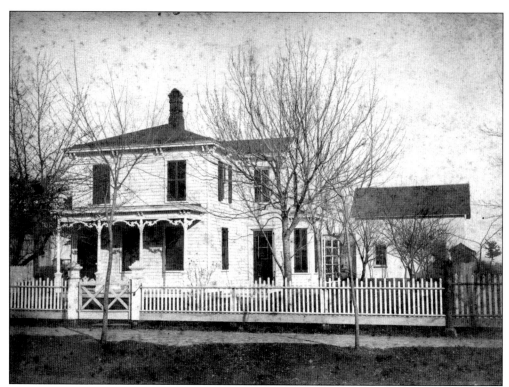

This late-19th-century photograph shows 178 South Country Road, which was built in the late 1880s by Frank Swezey, a builder and mill owner on Station Road. The house was remodeled in the early 20th century by Dr. Charles E. Lowe and his daughter Gertrude and eventually lost its Italianate touches to become more Greek Revival in style. (Courtesy Bellport-Brookhaven Historical Society.)

Three well-known Bellporters stand near South Country Road in this photograph from about 1900. From left to right, they are blacksmith Charles K. Shaw, whose son Donald became justice of the peace and later a real estate broker; W. Y. Baldwin, gardener for Brook Farm and Nearthebay; and Eugene Hulse, owner of the Bellport Laundry. (Courtesy Bellport-Brookhaven Historical Society.)

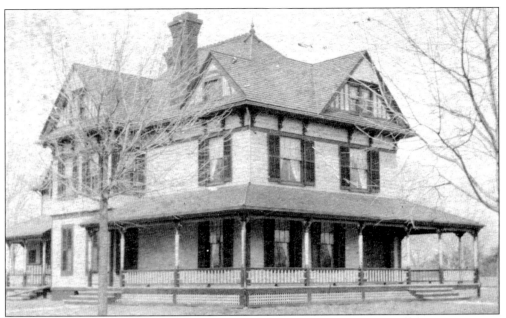

A postcard from about 1900 shows the house that Osborn Shaw inherited from his father at 197 South Country Road, east of North Brewster Lane. Built in the late 19th century in the Queen Anne style, it has a hipped roof with half-timbered, lower-cross gables and an asymmetrical wrap porch, all accentuated with strong colors typical of the Victorian period in America. (Courtesy Bellport-Brookhaven Historical Society.)

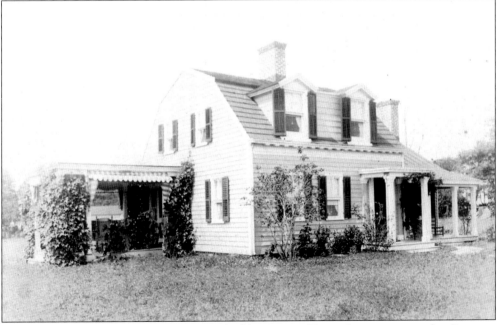

This Dutch Colonial house was photographed by Frances Toms after it was moved to Brewster Lane. The house was erected before 1858 and originally stood between 34 and 36 Bellport Lane. Built by the C. Rose family and later owned by the Stagg family, it was moved to 6 Brewster Lane after that street was established. (Courtesy Bellport-Brookhaven Historical Society.)

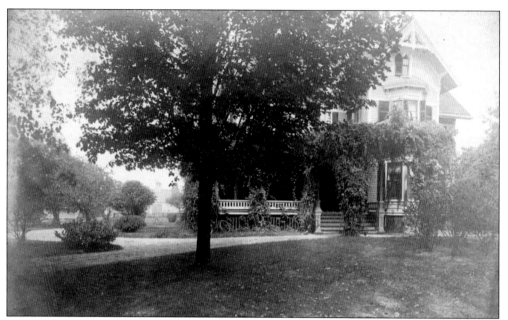

On the north side of South Country Road, directly across the street from the Otis-Edey estate at 76 South Country Road and behind a similar white picket fence, stood the summer home of Nathaniel Collins McLean, a Civil War general from Ohio who retired to Bellport. This large folk Victorian, known as the Messerole house by the late 1930s, was razed after World War II. (Courtesy Bellport-Brookhaven Historical Society.)

Shown here in 1955, the oldest part of 167 South Country Road at the corner of New Jersey Avenue is its eastern gambrel-roofed section, which dates from the 1830s. The western part was added around 1890. The original owner was Andrew Homan. Blacksmith Charles K. Shaw, son of blacksmith Joseph M. Shaw of 30 Bellport Lane, was given this house as a wedding present by the father of his bride, Harriet Watkins. (Courtesy Bellport-Brookhaven Historical Society.)

The building at 180 South Country Road replaced the original Presbyterian parsonage in 1873 when the earlier structure was moved a little to the south on Rector Street (Browns Lane). Allegedly a parson from the 1870s named Reverend Cooper kept an insane relative in the attic, so stories spread that the house was haunted. The house has retained its veranda and distinctive, elongated parlor floor windows. (Courtesy Robert Duckworth.)

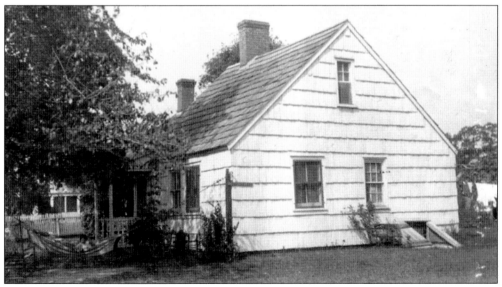

One of the oldest standing structures in Bellport is this mid-18th-century house, now part of Aldersgate, at 191 South Country Road. It existed at the time Justice Nathaniel Brewster owned most of the land that now comprises the village, and, reportedly, it housed his slaves. This undated photograph shows the house before being enveloped by additions. (Courtesy Bellport-Brookhaven Historical Society.)

This late-19th-century shingled house at 189 South Country Road was built for Edward R. Shaw, dean of pedagogy at New York University and son of the Bellport blacksmith Joseph Merritt Shaw. It was purchased by the Methodist Church in the 1940s after it acquired the sublime Presbyterian church building next door and named Wesley House. An addition to the church in 2001 has harmed the appearance of both. (Courtesy Robert Duckworth.)

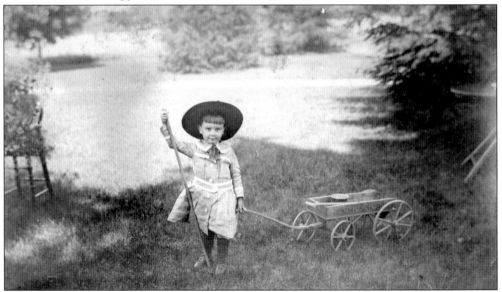

Pictured is James Otis Lyman at age three in 1886. He was the grandson of George T. Lyman and Sally Otis Lyman, who owned a 140-acre estate called Woodacres. The estate was located just outside the western border of Bellport in East Patchogue and adjacent to Francis A. Otis's estate, the Locusts. Part of Woodacres was combined with the Locusts to form the new Bellport Country Club. (Courtesy Gray Lyman.)

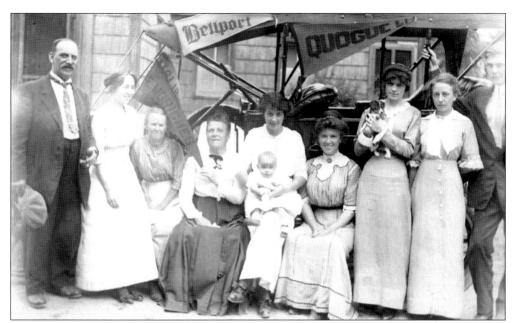

The Hulse family owned a taxi and storage company. Their home on Cottage Place was moved north to the east side of Station Road, and its barn became the Bellport Ambulance Company building. This picture, taken around 1913 in front of 9 Woodruff Street, shows the extended family and a motorcar festooned with pennants from various villages near Bellport. (Courtesy Al Sakaris.)

Pictured is Alda J. Woodruff, descendant of Mathew Edmund Woodruff, who built 9 Woodruff Street and who was one of the original purchasers of the old Brewster holdings that formed the heart of Bellport Village. The other buyers were Charles Osborn, Solomon Livingston, and Henry Hulse. In 1829, Mathew Woodruff and Henry Hulse sold their land to Capt. Thomas Bell and Capt. John Bell. (Courtesy Bellport-Brookhaven Historical Society.)

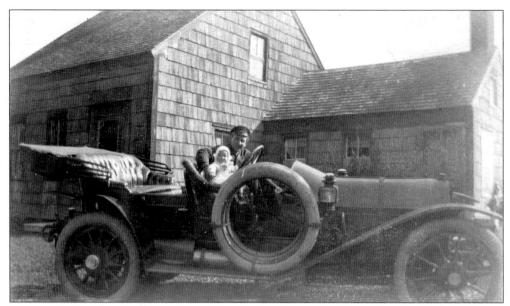

The home at 9 Woodruff Street was an indigenous example of the Long Island cape. Today remembered as the Eva Smith house, it was sold by Simeon Hulse in 1901 to Isaac Smith, Eva's father. Eva inherited it from her mother in 1937 and bequeathed it to the Bellport-Brookhaven Historical Society. It was torn down in 1989 for a parking lot. The image above shows Simeon Hulse with infant Eva around 1913. Below, the Smiths sit on their front lawn at 9 Woodruff Street. Behind them from the left are 8 Woodruff Street and 10 Woodruff Street. For generations, old Bellport families have lived in the Woodruff and Cottage Place neighborhood, a place forever changed when 9 Woodruff Street and other old buildings were destroyed. (Courtesy Al Sakaris.)

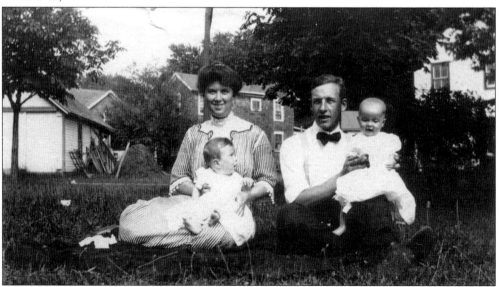

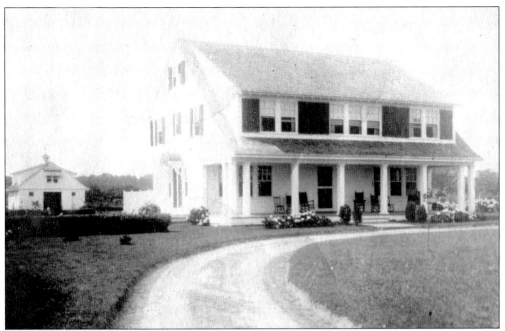

Pictured is See the Sea, a house built by John Davis Everitt and Madge Willard around 1914 that stood at 78 South Howells Point Road until 2004, when it was torn down for a studio commonly known as the copper house. (Courtesy John Everitt.)

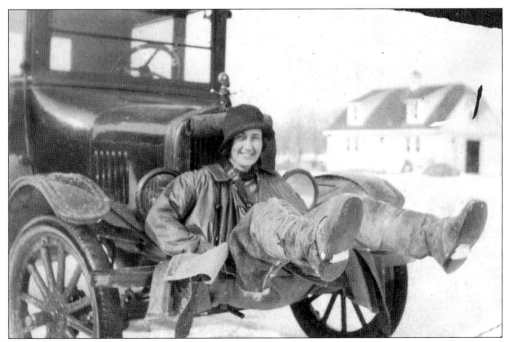

Eleanor "Billie" Everitt sits on the bumper of her automobile in this 1920s photograph taken on her property at 80 South Howells Point Road. Behind her is the barn that was behind See the Sea, the home of her in-laws. The copper house sits about where the barn used to be. (Courtesy John Everitt.)

The home at 8 Bayberry Lane, built by the Carman family around 1770, was moved to Bellport from Amityville in 1928 after being purchased by the attorney for James Walker, the mayor of New York. This house, together with the academy, became the catalyst for the historic preservation movement in Bellport in the 1990s. Owned by one of the founders of the historical society, Robert Pelletreau, the house was almost demolished after his death. It was saved by Mayor Frank Trotta, who used moral persuasion saying, "I speak for the house" to discourage the sale to prospective purchasers who wanted to tear it down. This close call energized the newly formed Bellport Historic Preservation Commission by facilitating its designation as a local historic landmark. Contrary to conventional thinking that as a landmark the house would be unsalable, it sold soon after designation to purchasers who had imagination and creativity, saw a singular opportunity, and understood and cherished the value and beauty of irreplaceable historic structures. Pictured is the house as it looked in its original location in Amityville. (Courtesy Radey Johnson and Jane Platt.)

This 1919 photograph shows little Peter Paige standing on the driveway of his parents' home, Cedar Bluff. The house was built around 1917 on part of the Edeys' estate, Nearthebay, as a wedding gift for Birdsall Otis Edey's daughter, Julia Paige. In the late 1980s, most of its water frontage was deeded away. (Courtesy Paige family.)

Pictured is 8 South Country Road, a house that once belonged to Capt. Barney King. King owned the first coal yard in Patchogue in 1889 and was the first assistant foreman of the Bellport Hook and Ladder Company. He also skippered a racing boat. Driftwood and nautical parts were used in the construction of the house. (Courtesy Robert Duckworth.)

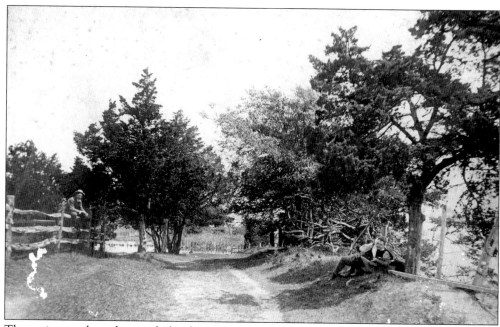

These pictures show the peat hole when it was part of Birdsall Otis Edey's property, Nearthebay. Willis Hawkins sits on a trail fence leading to the peat hole in the photograph above while other unidentified figures are nearby and at the pond itself in the photograph below. The peat hole, a shallow, two-acre pond that is a rare example of a fresh and saltwater habitat on Long Island, is a historic landscape with significance to Bellport's past as a farming community and later to its development as a resort. A place that has been continuously used by the community for summer and winter recreation, this unique ecological habitat was preserved from development when Brookhaven Town joined the Post-Morrow Foundation and Suffolk County's Land Preservation Partnership Program in raising the funds required for its purchase. (Courtesy Bellport-Brookhaven Historical Society.)

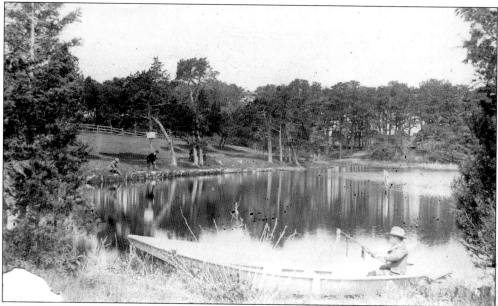

Two

HEART OF OLD BELLPORT

Bellport Lane became the village's first locally designated historic district in 2001. Often referred to as Bellport's signature street, this magnificent country boulevard begins at the four corners and sweeps gently down to the bay, disappearing into the dock. Wide and mostly lined with classic, white picket fences, Bellport Lane is an intensely satisfying street because of its lovely scale and architectural harmony. It virtually invites one to stroll on it and admire its beauty. It is gorgeous summer and winter, a monument to 19th-century American village design.

Bellport Lane was laid out after 1829 when Capts. Thomas and John Bell purchased land that became Bellville, then Bell Port, and finally, in 1861, Bellport. The Bell brothers established a dock and a road to the dock that became Bellport Avenue and then Bellport Lane. Families engaged in shipbuilding, farming, whaling, fishing, and hunting built houses on either side of this road. The architecture and history of Bellport Lane was surveyed in the first volume. In the early 20th century, the local firm of Armstrong and Pierman was responsible for modernizing many old houses on the lane and the lane was the beneficiary of this firm's understanding of respectful restoration.

The Hulse-Tuthill neighborhood is tucked between Bellport Lane and Browns Lane. Hulse Street, known as Rider Avenue at the dawn of the 20th century, was cut soon after Capt. Thomas Bell established Front Street (Shore Road) and Bay Street (Pearl Street) to connect Bellport Lane to Browns Lane. It was also nicknamed Pigs Alley. Tuthill Street, which was known as Homan Street in the mid-19th century, is perpendicular to Hulse Street and intersects it about midway.

Five historic structures grace this neighborhood, which has been a historic district since 2003. Of these, three homes were built between 1830 and 1850, including 7 Hulse Street, 15 Hulse Street, and 3 Tuthill Street. Sold off as a private residence in the mid-20th century, 5 Tuthill Street was once a barn on the property at 37 Bellport Lane. The structure at 1 Tuthill Street was built in 1888. If the quality of the environment is one of the great, but often unacknowledged, causes of both happiness and misery, then this tiny neighborhood, close to the bay and sheltered by two of Bellport's best-known streets, is the definition of beauty and happiness.

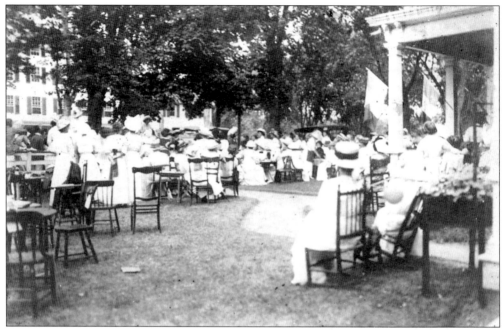

This photograph shows a women's suffrage meeting on the front lawn of 22 Bellport Lane in the summer of 1912. This Italianate house, built for Richard and Dency Gerard around 1876, was a teahouse when this picture was taken. Visible across Bellport Lane to the left is the Mallard Inn, formerly the Bell House. (Courtesy Bellport-Brookhaven Historical Society.)

This undated picture shows Dency Post Gerard on the left and Fanny Rider Osborn on the right. Gerard and her husband were the first occupants of 22 Bellport Lane. She was the daughter of Edward and Angeline Tooker Post. Osborn was married to Henry Nicholas Osborn. Her father was Capt. Charles Rider, the builder of 37 Bellport Lane. (Courtesy Bellport-Brookhaven Historical Society.)

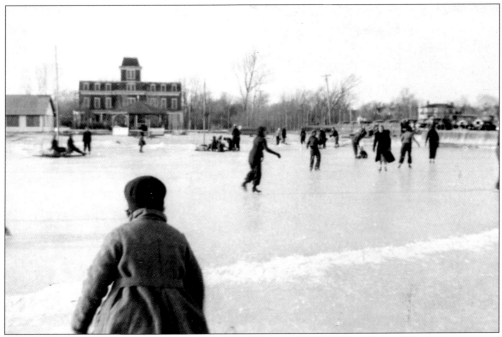

Recreation on the bay is shown in this 1930s photograph. The Bay House Hotel, just west of Bellport dock, was soon to be torn down after being a summer camp for Jewish working girls. (Courtesy Bellport-Brookhaven Historical Society.)

This article appeared in the *Patchogue Advance* on September 4, 1903, and described a Bellport in transition from a predominantly farming community of the mid-19th century to the summer resort community of the early 20th century. (Courtesy Virginia Waterman.)

BELLPORT

The J.H. Dolph cottage on Academy Lane has been sold to Mrs. Brown of New York City. Mr. Dolph has been coming to Bellport ever since its beauties were discovered by the noted artists of twenty-five and thirty years ago. Many of the old landmarks have changed and some have disappeared in that time. A number of the eccentric characters of those days furnished original ideas for painters that have since become famous. Bellport of thirty years ago was very different from Bellport of to-day.

The "summer border" was just beginning to be heard of. Capt. Joseph Bell sailed the first pleasure boat, the "Champion", from Bellport Dock. The picturesque "Cedars" were intact. The fish houses and net reels lined the shore and the bay was rich in its revenue. All the boys and some of the men went barefoot (now they go bareheaded) and three inch collars were unknown. There were no windmills (or gin mills) to mar the beauty of the scene, and householders never locked their doors at night. While we loose an artist in the departure of Mr. Dolph we gain one with the coming of Mrs. Brown. We welcome the coming and speed the parting guest.

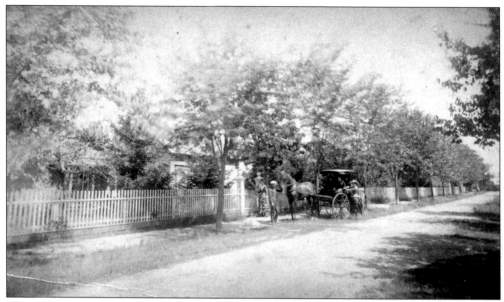

This 1880s photograph pictures the west side of Bellport Lane. The figures are in front of the C. Rose home built in the 1850s. The Roses were early settlers of Brookhaven. In the early 20th century, the house was moved to 6 Brewster Lane and is pictured in the previous chapter. (Courtesy Bellport-Brookhaven Historical Society.)

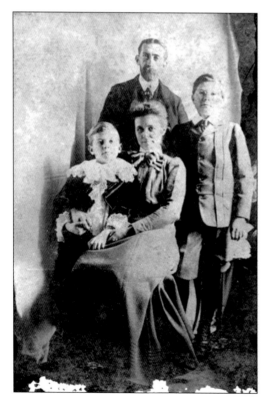

Pictured in this 1890s photograph are Edmund F. Hawkins, his wife, Martie, and their two sons, Gerard and his older brother, Robert. The Hawkins family established a drugstore in 1896 at 13 Bellport Lane. (Courtesy Bellport-Brookhaven Historical Society.)

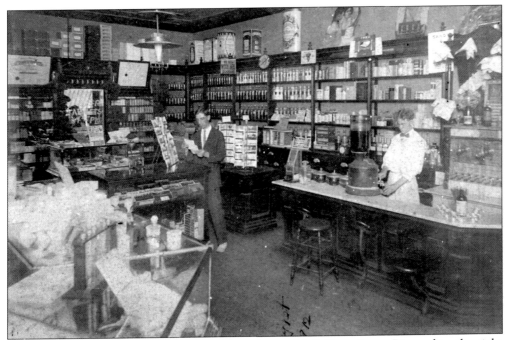

By 1912, the Havens Drug Store was in operation at 13 Bellport Lane. Pictured to the right behind the counter is William Havens. The store later became Villano Plumbers, and today a tailor shop is there. (Courtesy Bellport-Brookhaven Historical Society.)

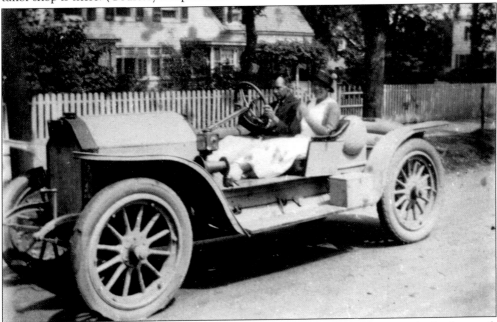

Mary Mallory is seen in her motorcar around 1916 with 37 Bellport Lane in the background. The driver is unidentified. The picture was taken from the front yard of her home at 36 Bellport Lane. She became Mary Janvier and later inherited the house her mother purchased from the Homan family, eventually selling it to the Bianchi family. (Courtesy Bellport-Brookhaven Historical Society.)

The oldest section of 36 Bellport Lane, seen here around 1930, is its southern half. The house also once had a veranda. Many alterations were made on Bellport Lane. Porches were added or removed, and houses were enlarged with wings or additional floors. Yet, consciously or not, the changes that were made respected the scale, proportions, and existing elements of the street. The result was a splendid legacy for future generations. (Courtesy Bellport-Brookhaven Historical Society.)

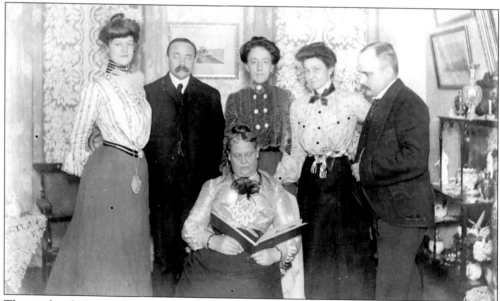

This undated picture shows members of the Osborn and Homan families at home. Charlotte Osborn is seated, and standing left to right are Carolyn Osborn, unidentified, Josephine Post Homan, unidentified, and Forrest Post Homan. The Osborn and Homan families were among the earliest in Bellport and were large property owners. (Courtesy Bellport-Brookhaven Historical Society.)

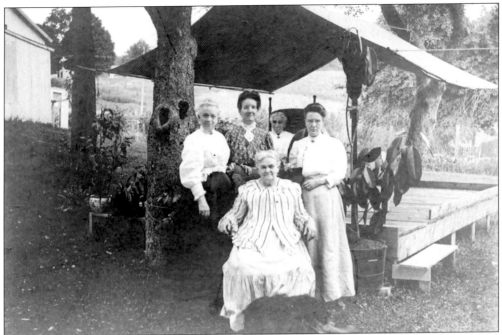

This 1907 photograph shows Martha Gerard Bell seated and surrounded by relatives and friends. From left to right are Fanny Gillette Rider Osborn, Emma Allilson (adopted daughter of Martha Bell), Clarice Edwin Post, and Emma Hawkins. (Courtesy Bellport-Brookhaven Historical Society.)

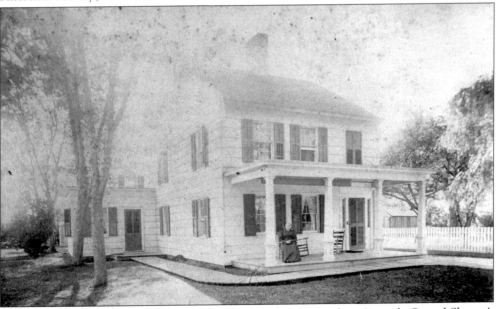

Sitting on her veranda at 30 Bellport Lane around 1900 is Caroline Amanda Gerard Shaw. A veranda, or full front porch, was called a piazza in this area about 100 years ago. The Shaws were blacksmiths, and for many years, a blacksmith shop stood on their property. It is now on the grounds of the historical society. The house lost its porch in 1976 during Hurricane Belle. (Courtesy Bellport-Brookhaven Historical Society.)

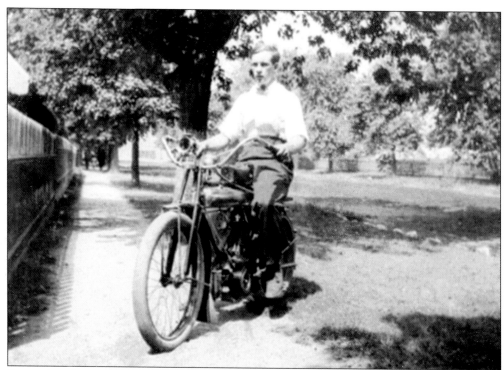

Pictured on his motorized bicycle on Bellport Lane around 1910 is Isaac Smith. He is facing 40 Bellport Lane, where Dr. Baldwin lived and who people went to see if "you ate too much crab meat." (Courtesy Al Sakaris.)

This photograph shows 33 Bellport Lane as it looked in 1921 when it was the summer home of Genevieve Earle, the first woman ever elected to the New York City Council. Earle purchased the house, built for Jacob Bell, in 1920. After serving five terms on the council, she retired to Bellport in 1949. (Courtesy Bellport-Brookhaven Historical Society.)

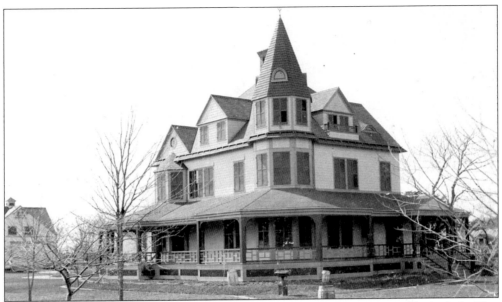

This late-19th-century photograph shows 42 Bellport Lane as it originally looked. This high-styled Queen Anne house, built for Thomas Johnson, features a corner tower, hipped roof, cross gables, wrap porch, clamshell surface decoration, and bold color. Its barn, seen on the left, is now 25 Academy Lane. Today the house is missing its third-floor east-facing gable and its clamshell shingles. (Courtesy Bellport-Brookhaven Historical Society.)

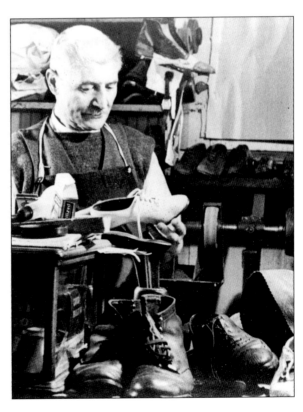

This 1902 picture shows Angelo De Santis at work in his first cobbler shop at 9 Bellport Lane. His second shop was at 145 South Country Road. (Courtesy Bellport-Brookhaven Historical Society.)

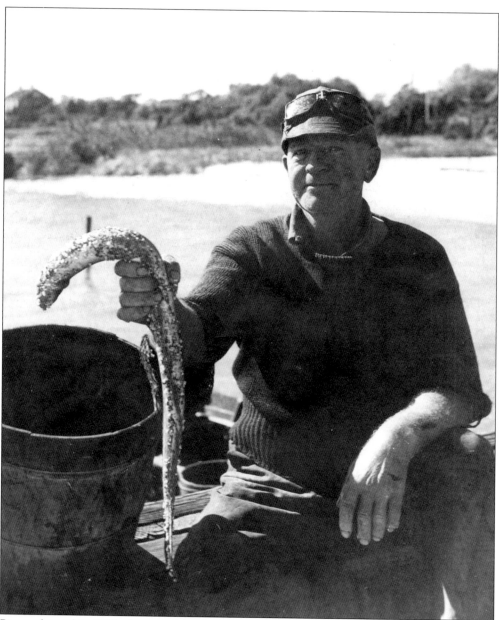

Pictured in this 1955 photograph, taken by amateur photographer and benefactor of the historical society, Florence Crowell, is Capt. Sam Petersen, who made his living fishing on the bay harvesting eel, blowfish, clams, and oysters. Petersen lived at 47 Bellport Lane with his wife, Madelaine Gardiner, and supposedly had a pet seagull named Nicademus. He built the diminutive building at 8 Bellport Lane as a fish store (today's Carla Marla Ice Cream Store) for his nephew Paul Groh. Groh later moved to larger quarters at the southeast corner of the four corners where his father's real estate office had been. While living in Bellport, Petersen, who had served in the Danish navy, became a good friend of Augie Hermansen, who worked for Maj. William H. Langley and had been in the Royal Norwegian Navy. Both had immigrated to the United States, found their way to Bellport, and became acquainted there. (Courtesy Bellport-Brookhaven Historical Society.)

A farmers' picnic parade was held in Bellport in the 1930s. Here is the farmer's wagon, driven by Charles Hawkins and filled with young people. The parade was a reminder of the farming community that was old Bellport and celebrated its most cherished possession: simplicity. The group is on the dock at the foot of Bellport Lane. (Courtesy Bellport-Brookhaven Historical Society.)

This undated Christmas card sent from Hulse Street calls the street by its ancient name, Pig Alley. The original name for this street was Rich's Lane, but by 1858, it was called Hulse Street. By 1900, it became Rider Avenue but soon reverted to Hulse Street again. (Courtesy Bellport-Brookhaven Historical Society.)

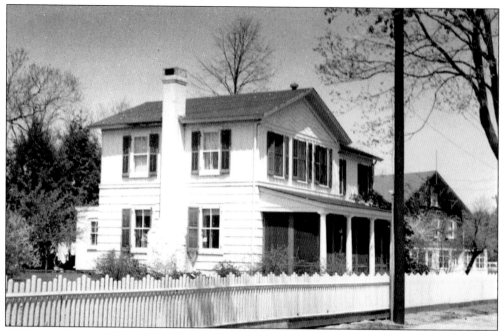

This Greek Revival home at 15 Hulse Street was built before 1853 and sold by Oliver Hazard Perry Robinson to Thomas Camerden. The house has an unusual, wavy design in the surface pattern of the wall cladding beneath the gable, as can be seen in this 1950s photograph. (Courtesy Bellport-Brookhaven Historical Society.)

Standing next to the family's motorcar on the Bellport dock in this photograph from about 1930 is Isabelle Bumstead Meachen, Forrest and Maude Bumstead's only child, who lived with her family at 11 Fourth Street. She was a court stenographer at the Patchogue courthouse. (Courtesy Forrest Meachen.)

West of Bellport Lane off Shore Road was the short-lived Bellport Pool, formed by two bulkheads and a screen at the south end. The bay bottom was dredged for depth, and the screen kept seaweed and jellyfish out. Dorothy Hermansen is seen here in the pool in 1926, and behind her is Howard Houston, son of Maj. William H. Langley's cook. (Courtesy Dorothy Maggio.)

The Bellport Pool also had a beach between it and Shore Road, where, years earlier, Will Overton had a boatyard. This 1926 photograph shows Hermansen at the beach, and in the background, parked cars on the dock are visible. (Courtesy Dorothy Maggio.)

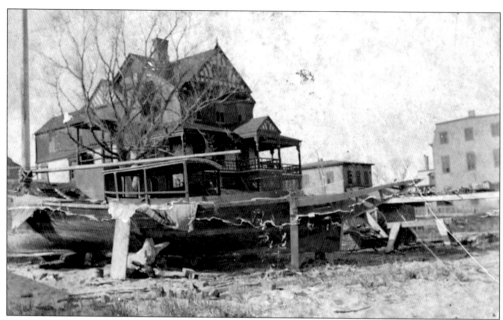

Pictured in the 1890s is Will Overton's boatyard that was replaced by the Bellport Pool's beach. Overton also had a larger operation that included a coal yard and boat slip on the east side of the Bellport dock. It was referred to as the Overton Slip. Seen above the boatyard is 2 Shore Road, and on the right is the west facade of the Bay House Hotel. (Courtesy Bellport-Brookhaven Historical Society.)

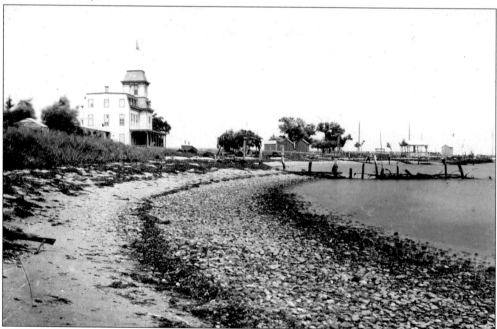

Directly north of this shoreline position was the smaller of Overton's boatyards that was replaced by the pool beach. The view here is east, and the Bay House Hotel is prominent to the left. To the right is the hotel's gazebo, a replica of which stands in the same spot today, and in between are three bathhouses. (Courtesy Bellport-Brookhaven Historical Society.)

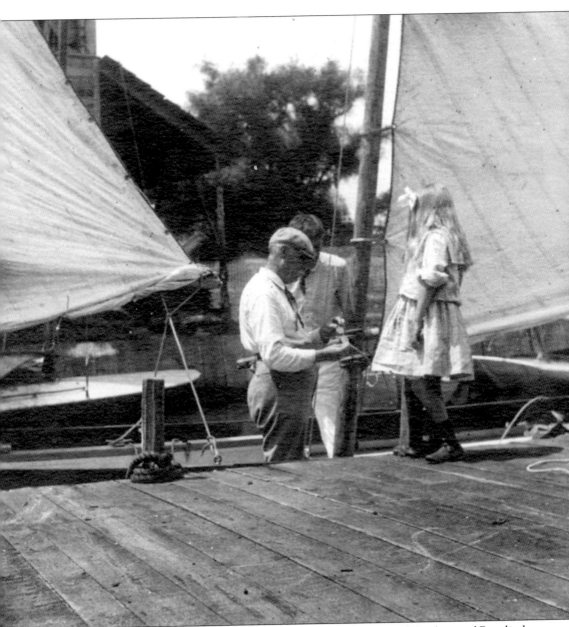

This photograph from 1905 shows, from left to right, Dr. J. G. Noble, Paul Bigelow, and Rosalind Bigelow on the Bellport dock adjacent to the Overton Slip with the *Quinnepiac*. Paul was commodore of the yacht club from 1924 to 1926 and on its race committee for many years. About the time when this picture was taken, a popular boat designed by Bellport yachtsmen was the Bellport Bay one design sloop, or BB. Eleven of the BB-style boats were built at the Overton Slip from 1907 to 1922 and the names of these boats always contained the word *lady*. Yacht racing in the early 20th century was very different than today. The captains did all the drudgery—rowing out to the mooring to get the boat, hoisting the sail, furling the sail at the end of the day, and returning it to its mooring—while the skipper merely enjoyed the sailing. To complicate matters, there was also rivalry among the captains. (Courtesy Bellport-Brookhaven Historical Society.)

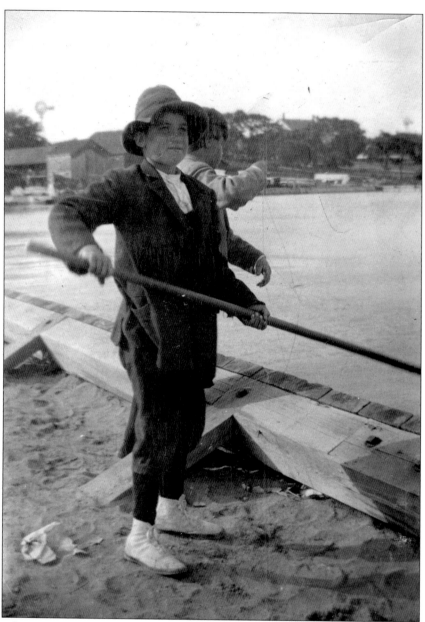

The two boys in this photograph from about 1914 are not identified, but what they are doing is familiar to all who stroll down Bellport Lane to the dock on a summer's evening. Crabbing from the dock is a pastime that has been enjoyed for generations, and youngsters who are accompanied by their parents to the dock typically get crabbing tips from them, as this boy seems to be heeding. Behind the boys on the shore just to the east of Bellport Lane, a windmill rises over the Overton shipyard buildings and slip. The land they occupied, adjacent to the rowboat beach and owned by the Osborns, later became Osborn Park. To the right on the shore, the roof of the main Goldthwaite cottage is visible. On the opposite side of the dock, the shore view included the Bay House Hotel and its gazebo. Both appear from the vantage point of the dock in two paintings by William Glackens, *Vacation Home* of 1911 and *After Bathing, Vacation Home* of 1913. (Courtesy Bellport-Brookhaven Historical Society.)

Three

BELL STREET

In his 1921 book, *Loafing Down Long Island*, Charles Hanson Towne describes a hiker who comes upon Bellport and notices its "charming little houses, some of which rest neatly on the ground, as though they had no cellars, and give the impression of well constructed scenery in a light opera." The scenery so reported might have been that of the neighborhood of Bell Street, a street where the majority of the houses were built by the same firm on compact lots. For the most part, houses on Bell Street vary by the number of windows across the front and the eastward or westward position of their side gables. The charm of the street comes from the subtle variations of the same basic design.

The Bell Street historic district was created in 2002. The Bell Estate was surveyed and subdivided in 1882, and most of the houses on Bell Street were built between that date and the end of the 19th century. What is unique about this street is that one firm built most of the houses and was headquartered there in a building still standing that, until very recently, was still in commercial use. The Robinson and Watkins building, referred to today as the Ralph Brown building in honor of the man who bequeathed it to the Bellport-Brookhaven Historical Society in 1980, exemplifies a noble plainness in commercial architecture that was once common on Long Island and is now rare.

Robinson and Watkins was an important Bellport builder that preceded the firm of Armstrong and Pierman and was active from the last quarter of the 19th century through the early part of the 20th century. Besides dwellings and bathhouses, the firm constructed the original firehouse in 1893 and the Catholic church in 1904. It even ran a hardware store. Of the 15 homes on this street, one can see this contractor's handiwork in the 11 similar, simplified Queen Anne houses that were built in the last 20 years of the 19th century. The four other houses are from the dawn of the 20th century to the 1920s.

Bell Street is distinctive in that it documents a late-19th-century development that was both residential and commercial. The mix of uses today is similar to what it was 100 years ago and remains harmonious.

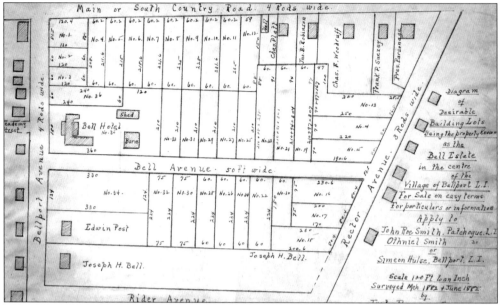

The 1882 survey of the Bell Estate shows how Capt. Thomas Bell's property was subdivided after his death. The Bell Hotel, formerly the double home of the Bell brothers and later a rooming house for the students at the Bellport Classical Institute, had become a proper hotel. Most of the subdivided land was Bell's apple orchard, and the proposed street was named Bell Avenue. (Courtesy Bellport-Brookhaven Historical Society.)

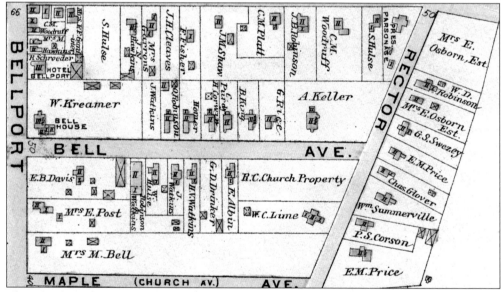

This map from about 1900 shows Bell Street in detail. The Kreamer property (Bell House) today holds a parking lot, 9 Bell Street, and the old firehouse. The adjacent Watkins lot is occupied by 13 Bell Street. Next on the north side of the street (from left to right and marked II) are street numbers 17, 19, 21, 23, 25, 27, and the Keller house. On the south side of the street are 6 Bell Street, the livery at 10 Bell Street, and the Robinson and Watkins building at 12 Bell Street. Next are 14, 16, 20, and 24. The west part of the former Catholic church property became 26 Bell Street. (Courtesy Bellport-Brookhaven Historical Society.)

Birds Eye view of Bellport, L. I.

In this late-19th-century postcard of Bell Street, several buildings can be identified. From far left to right, one can see 17 (on the north side of the street) and 24, 20, 16, 14, 12, 10, and 6 Bell Street on the south side. Not seen here but also standing at this time are 19, 21, 23, 25, and 27 Bell Street. (Courtesy Bellport-Brookhaven Historical Society.)

The home at 24 Bell Street, a folk Victorian with delicate carvings and modest Queen Anne detailing, is not dissimilar from the five other three-bay houses on the street. Except for its hipped roof, it is almost identical to the others, if one looks beyond the changes made to the other five through the years. (Courtesy Robert Duckworth.)

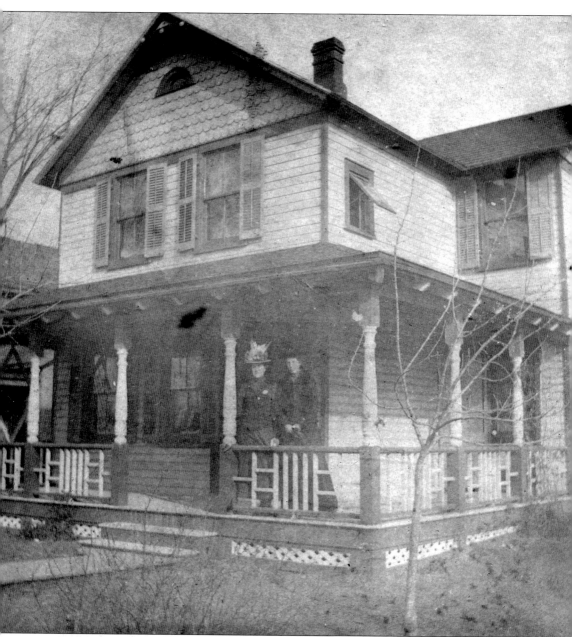

This period photograph shows 6 Bell Street with May Price (left) and Grace Gould standing on its wrap porch. Price was one of the five daughters of Everett Price, the first mayor of Bellport. She and Gould appear to be visiting the Davis family. The livery is seen on the left. This house, with its west-facing second gable, is adorned with clamshell shingles under the eaves. Together with 14, 19, and 20 Bell Street, it exemplifies the Robinson and Watkins firm's two-bay design while the variations seen today document the changes made to this basic style. (Courtesy Bellport-Brookhaven Historical Society.)

This *c.* 1910 postcard picture was taken in front of 6 Bell Street and shows the street looking east. The Davis family lived here and owned the livery on the right. Later the Wyandotte Garage briefly occupied the livery building. The Robinson and Watkins building stands east of the livery at 12 Bell Street. Visible at the end of the street is 7 Browns Lane. (Courtesy Bellport-Brookhaven Historical Society.)

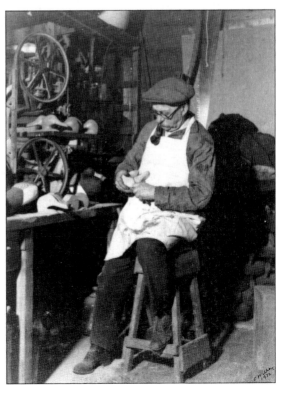

"They enjoy the reputation of being the best in their line and the splendid specimens of their work are silent though eloquent recommendation." The *Patchogue Advance* used these words to praise the firm of Robinson and Watkins in an article dated August 14, 1914. Pictured in this 1932 photograph is the retired head of the firm, James Watkins, carving decoys. (Courtesy Bellport-Brookhaven Historical Society.)

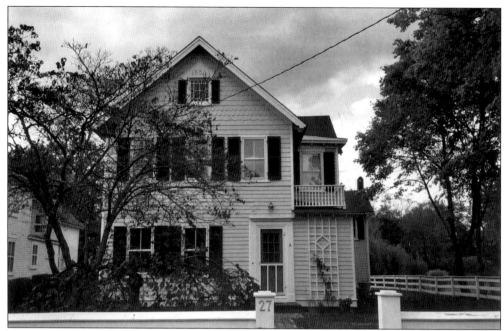

The 1889 house at 27 Bell Street (above) is a three-bay front gable design where the section of the porch that wraps to the east-facing wing was incorporated into the ground floor interior. The front part of the porch was removed, and the house has grown deep into its lot to accommodate growing families. Despite the changes made to the front and the increased square footage, the facade has remained in tune with the streetscape. East of this house on the same side of the street is a lot owned by the Catholic Church that once held an imposing Queen Anne house (below). In the 1930s, the church tore down the house to construct a parochial school on the lot. Permission to build the school was denied by the village, and the lot has remained empty. (Courtesy Robert Duckworth.)

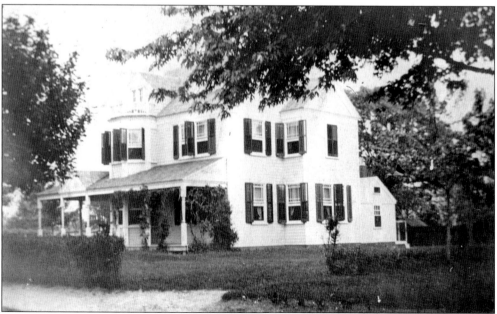

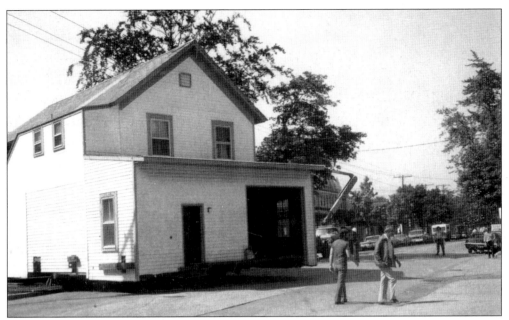

The original Bellport Hook and Ladder Company truck house, built by Robinson and Watkins in 1893 for $750, was located at the same location as the current firehouse. It was moved to Woodruff Street when the new firehouse was constructed in 1937 and moved to Bell Street in 1975, when the firehouse was enlarged. This picture shows the firehouse being pulled to its new foundation on Bell Street. (Courtesy Emily Czaja.)

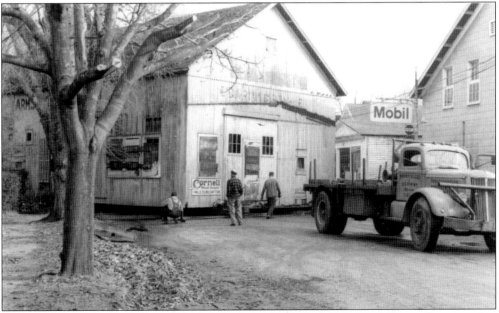

In 1901, the *Brooklyn Eagle* described Bellport as a place of "peripatetic houses," noting that "when a site is wanted, they move them." The same statement can be applied to commercial structures, as this 1968 photograph shows. The Pierman Barn was moved from its old location north of Bell Street to its new location south of Bell Street. It is now the museum of the historical society. (Courtesy Bellport-Brookhaven Historical Society.)

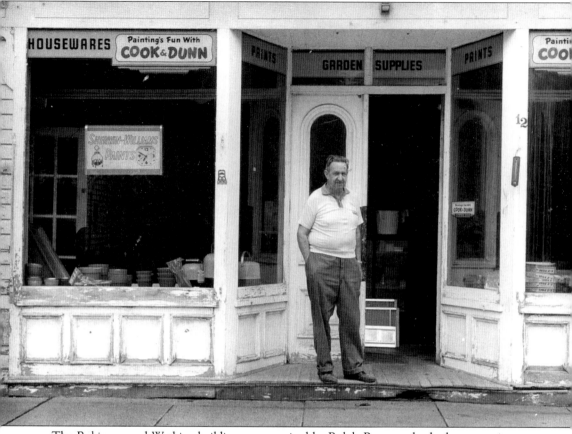

The Robinson and Watkins building was acquired by Ralph Brown, who had a reputation as an eccentric. He operated a hardware store at the premises and enjoyed joking with his customers, telling them that "I don't have any of those today," before they could ask him if he had what it was they wanted. Brown was robbed of his prized coin collection that he kept at the store and murdered there in 1980. He bequeathed the building to the historical society, which named it in his honor. The structure at 12 Bell Street has a lean-to addition to its east and a two-and-a-half-story warehouse in the rear. Pictured is Brown standing in front of his hardware store in 1972. (Courtesy Bellport-Brookhaven Historical Society.)

Four

BROWNS LANE

Browns Lane is the oldest street in Bellport, and it predates the village. It probably was a Native American trail to the bay. Through the first part of the 20th century, it was called Rector Avenue after the Presbyterian rectory or parsonage that was on the corner of Browns Lane and South Country Road opposite the Presbyterian (now Methodist) church. It was then renamed Browns Lane for Oliver Hazard Perry Robinson's father-in-law, George Brown.

The majority of houses in the Browns Lane Historic District date from the third and fourth quarters of the 19th century, with most houses on the east side of the street above Maple Street built by the Robinson and Watkins firm. The important hotels of Bellport's hotel era were located on this street. The Goldthwaite's cottages faced the bay on the west side of Browns Lane above Front Street (Shore Road). The Wyandotte was on the east side of the street, and the entrance to its grounds was just north of where Raynor Street is today. In the first quarter of the 19th century, Capt. Joseph Marvin had a shipyard at the foot of Browns Lane and owned two houses there, the second of which survives in the guise of a Swiss chalet at 30 Browns Lane. The home of Robinson, the inventor of the ball bearing, was moved in 1918 to where Marvin's first home stood. The house of Robinson's son at 9 Browns Lane still stands, as does the Carpenter Gothic house of Bellport's first mayor, Everett Price. The earliest existing house on the street, built by the Petty family before 1858, is at its original location as the southern section of a larger old house, while the original parsonage that stood near South Country Road was moved further south and transformed in the 1930s from a saltbox to a Colonial Revival.

Browns Lane, a street that is rich in history and architectural interest, became a historic district in 2004. The beauty of Browns Lane, as with other historic districts in Bellport, is that the original spacing and scale remain unchanged, and the values that created the street are still in evidence. Julia Morgan, the architect of the Hearst Castle in California, once said, "My buildings will be my legacy . . . they will speak for me long after I'm gone." The appearance of Browns Lane speaks volumes for the culture that created Bellport.

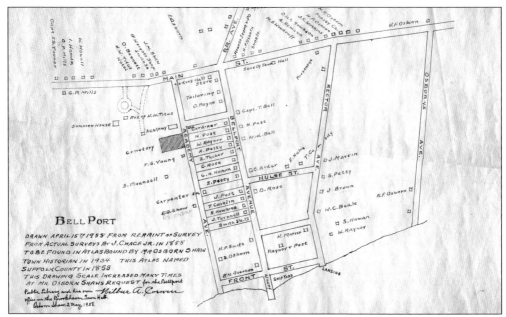

An 1858 map of Bellport shows the earliest houses on Rector Avenue (Browns Lane) were the Presbyterian parsonage and a cluster of homes opposite Hulse Street. Three structures survive in altered states, the relocated parsonage, the Petty house, and the W. C. Beale house, which became the "Tea Box." Most of the land on the east side of Rector Avenue belonged to the Osborns, and on the west side, it belonged to the Bells. (Courtesy Bellport-Brookhaven Historical Society.)

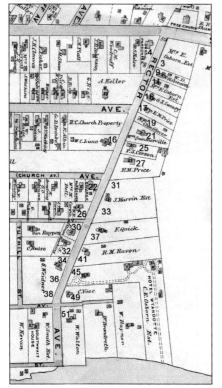

Superimposed on this map of Rector Avenue from about 1900 are the houses that exist today. Twelve homes, including 3, 9, 11, 15, 16, 17, 19, 21, 25, 26, 27, and 34 Browns Lane, were built from the 1870s to the early 20th century, most by Robinson and Watkins. The homes at 4, 30, 32, 33, 37, 41, 49, and 51 Browns Lane date from the mid-19th century, and the homes at 4, 26, and 33 Browns Lane were moved to their present locations. Five houses at 22, 31, 36, 38, and 45 Browns Lane were built in the 20th century. (Courtesy Bellport-Brookhaven Historical Society.)

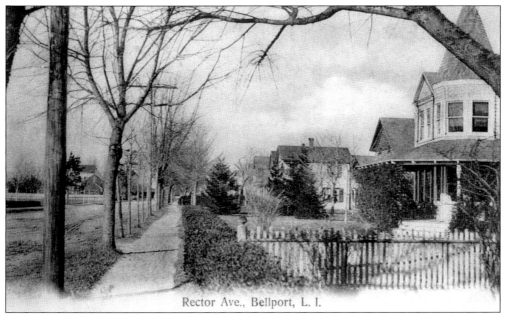

Rector Ave., Bellport, L. I.

This early-20th-century postcard is a north view from 25 Browns Lane, a Queen Anne–style home and one of three in Bellport that has a turret. Also seen from south to north on the same side of the street are 21, 19, 17, and 15 Browns Lane. On the left side of the street is the repositioned old parsonage building before its 1930s remodeling. (Courtesy Bellport-Brookhaven Historical Society.)

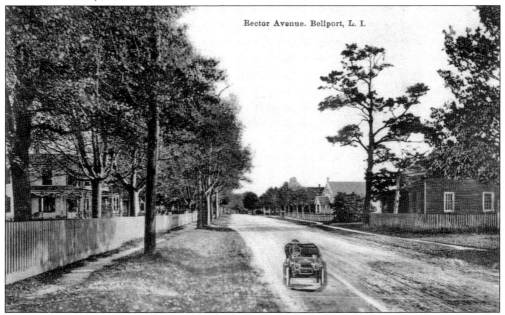

Rector Avenue. Bellport, L. I.

A southerly view of Browns Lane around 1910 is depicted on this postcard. On the right is the original parsonage building in the location it has occupied since 1873. South of it is the Catholic church. In the foreground is a velocipede, a vehicle created by Oliver Hazard Perry Robinson that was made possible by his invention of the ball bearing. (Courtesy Bellport-Brookhaven Historical Society.)

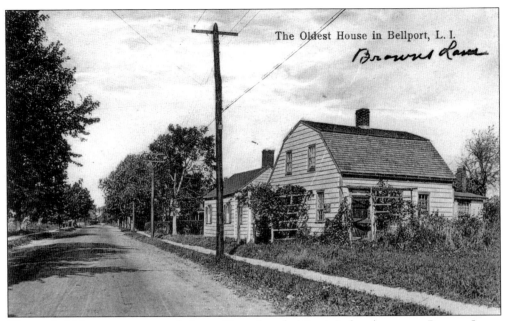

This early-20th-century postcard shows Capt. Joseph Marvin's first house on Browns Lane, which stood on the east side of the street south of where Price Street is today. It was torn down after 1915, and two lots were created. In 1918, George Kreamer moved the Robinson house from South Country Road to the south lot at 33 Browns Lane and added a floor. (Courtesy Bellport-Brookhaven Historical Society.)

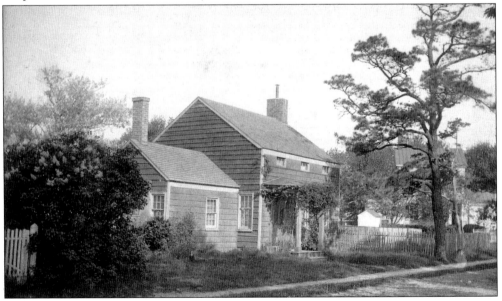

Frances Toms photographed the old parsonage building around 1908. Toms, a woman photographer at a time when most photographers were men, left a legacy that documents life in early-20th-century Bellport. The parsonage, originally closer to South Country Road, was moved south when a new rectory was built in 1873. Charles Marvin purchased it in 1922, and by 1935, it was remodeled as the Colonial Revival–style structure seen today at 4 Browns Lane. (Courtesy Bellport-Brookhaven Historical Society.)

The first Methodist church in Bellport, built in the third quarter of the 19th century, stood at the corner of Rector and Maple Streets until 1945, when the congregation outgrew the building. This postcard looks south from the corner. A mid-20th-century gambrel-roof Colonial at 22 Browns Lane is now at the church's site. To the left across the street is Capt. Joseph Marvin's first house. (Courtesy Bellport-Brookhaven Historical Society.)

Mimie Blanche Raynor, whose family was involved in the shipbuilding firm of Post and Raynor and whose grandfather was Hiram Post, builder of 31 Bellport Lane, played the organ at the first Methodist church in Bellport. (Courtesy Bellport-Brookhaven Historical Society.)

M. Edith Brundage,

OCEAN AVENUE,
PATCHOGUE, L. I.

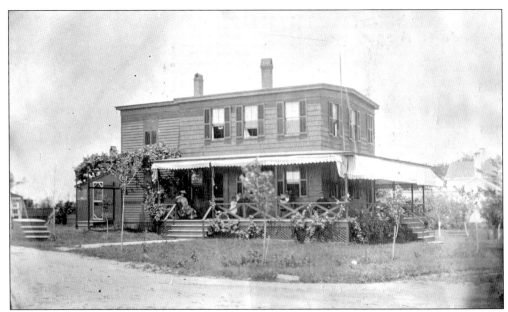

Pictured in the c. 1881 image above is 49 Browns Lane when it was owned by William C. Beale. Later owners included George Stebbins, Caroline Goldthwaite, Clarence Vose, Molly Dougherty, and until very recently, the Streit family. When the Goldthwaites owned it, they took in guests and added rooms, and by about 1890, the house had two additional sections on its right side, as can be seen in the photograph below. With its flat roof and rectilinear shape, it actually resembled a giant box of tea and was nicknamed the "Tea Box." Just north of the Tea Box was the entrance to the Wyandotte Hotel, and to the left, a Wyandotte cottage is visible. This cottage was later moved across the street. (Courtesy Bellport-Brookhaven Historical Society.)

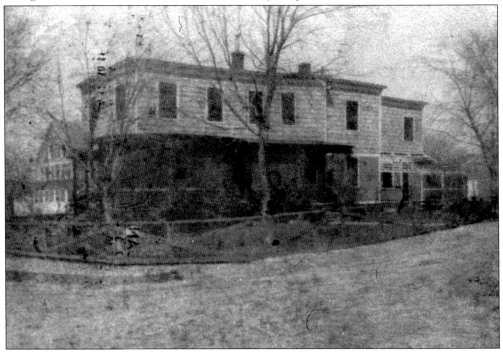

Pictured is Frances Platt Goldthwaite, who owned the boardinghouse called the Tea Box and who later, with her husband, operated the Goldthwaite Inn, a much-loved Bellport hotel. When the Goldthwaite property was redeveloped in the late 1930s, one of its cottages was moved west and became 8 Pearl Street. (Courtesy Bellport-Brookhaven Historical Society.)

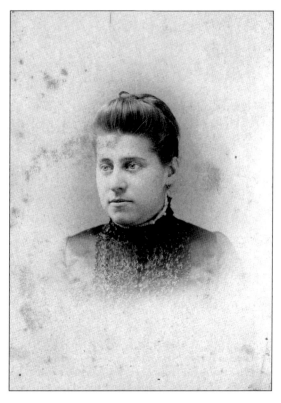

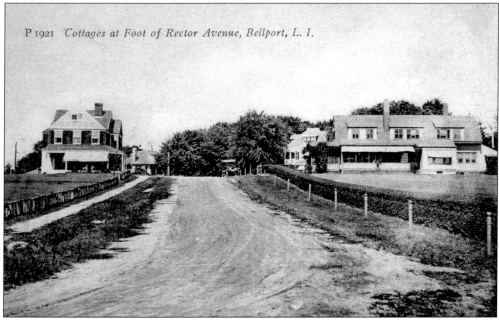

P 1921 'Cottages at Foot of Rector Avenue, Bellport, L. I.

This postcard from about 1900 shows Browns Lane from the south. To the left is a Goldthwaite cottage, and to the right is 51 Browns Lane. Behind 51 Browns Lane stands the Tea Box after undergoing an Edwardian remodeling that included peaking its roof and adding dormers and an octagonal lookout. (Courtesy Bellport-Brookhaven Historical Society.)

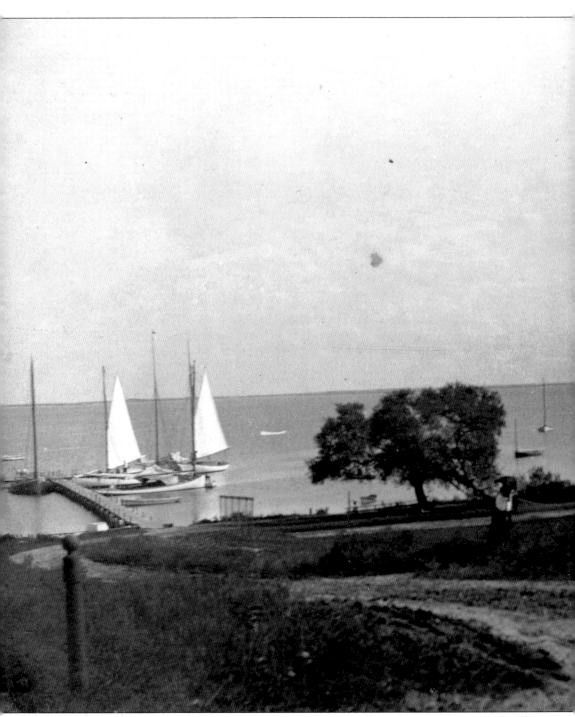

The romance of Bellport is conveyed in the special quality of this charming photograph, taken by Frances Toms (1869–1948). In the August 19, 1904, issue of the *Patchogue Advance*, Toms advertised "that she will do all kinds of photographic work for those of our visitors who wish to acquire souvenirs of Bellport." Toms captures the beauty of the Goldthwaite's setting in this picture taken in 1906. The view is southwest, and the guests are enjoying the grounds of the

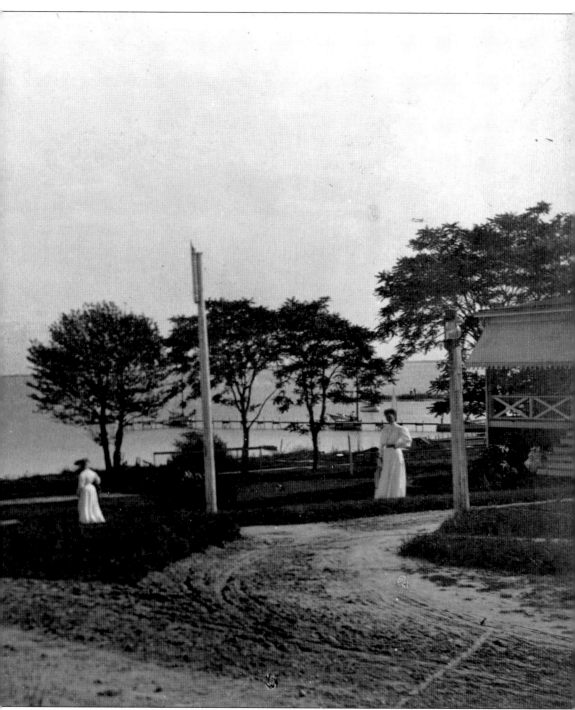

hotel. The piazza of the main building is to the right, and Rector Avenue is in the foreground. The scene was much busier 75 years earlier, as Capt. Joseph Marvin had a boatyard at the foot of the lane. In this picture, however, only the Goldthwaite dock is there, and all is peaceful. (Courtesy Bellport-Brookhaven Historical Society.)

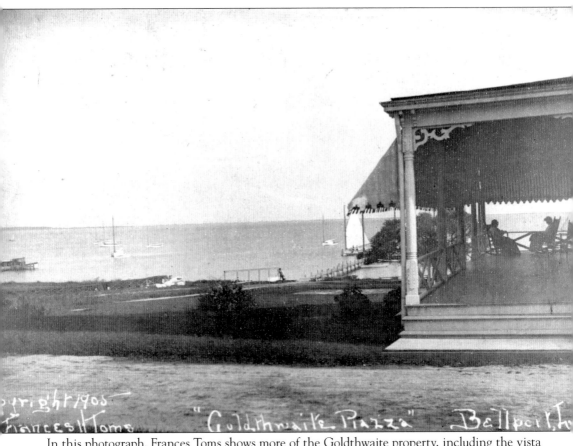

In this photograph, Frances Toms shows more of the Goldthwaite property, including the vista of the bay from just outside the hotel's piazza or veranda. The view is south, and a striped awning has been hung over the south and east exposures of the piazza. The old willow tree, a landmark depicted in many postcards of the era, is at the shoreline, and a sailboat is about to arrive at its dock. Before Bellport had its own station, guests arrived at the hotels in Bellport by stagecoach from the Patchogue train station and later by motorcar taxi service. To go to the ocean beach, they could hire a captain to sail them to the Great South Beach, or Fire Island. (Courtesy Bellport-Brookhaven Historical Society.)

The little boy in the goat carriage is Willie Walton, seen here in front of a Wyandotte cottage that is visible to the left of the Tea Box in a previous picture and also below. In the late 19th century when George Wicks ran the Wyandotte Hotel, it was fashioned as a rustic retreat and the stick style of this 1892 building, today at 26 Browns Lane, complemented this fashion. (Courtesy Bellport-Brookhaven Historical Society.)

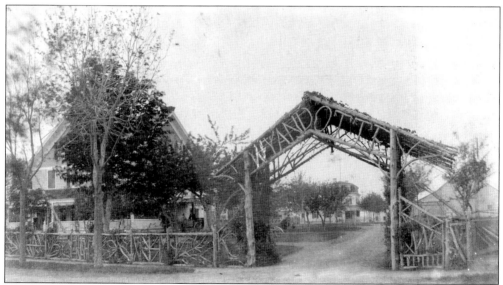

The entrance to the Wyandotte Hotel on Browns Lane in the 1890s had a rustic portal and fence built by George Hamlyn. Today 45 Browns Lane replaces the portal. Framed by the entry is the main building with its mansard roof. The four-acre Wyandotte property went from Browns Lane to about where Brewster Lane is today, making a right angle south to the bay. (Courtesy Bellport-Brookhaven Historical Society.)

Seated near the main building of the Wyandotte is Emily Hamlyn. She and her husband, George, were employed at the Wyandotte Hotel. George worked on the grounds and buildings, while Emily was a chambermaid. (Courtesy Jean Steele.)

Pictured in the front yard of 26 Browns Lane at the dawn of the 20th century is Marie Louise Hamel, mother of Wilbur R. Corwin's wife. The Corwin family has been in Bellport for almost two centuries. Behind Hamel, 37 Browns Lane is seen, looking very much as it does today. (Courtesy Bellport-Brookhaven Historical Society.)

The home at 19 Browns Lane, located on the northeast part of the street, was built by the firm of Robinson and Watkins in the last quarter of the 19th century for the Glover family. It exemplifies the firm's two-bay front gable design seen most commonly on Bell Street. The rear yard of this property holds a gravestone for a horse named Kit. (Courtesy Robert Duckworth.)

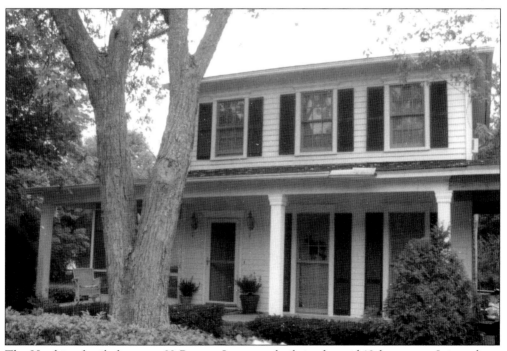

The Hawkins family home at 32 Browns Lane was built in the mid-19th century. It is perhaps the strongest example of the Greek Revival style in the village, with its hipped roof, squared columns, and elongated parlor floor windows. (Courtesy Robert Duckworth.)

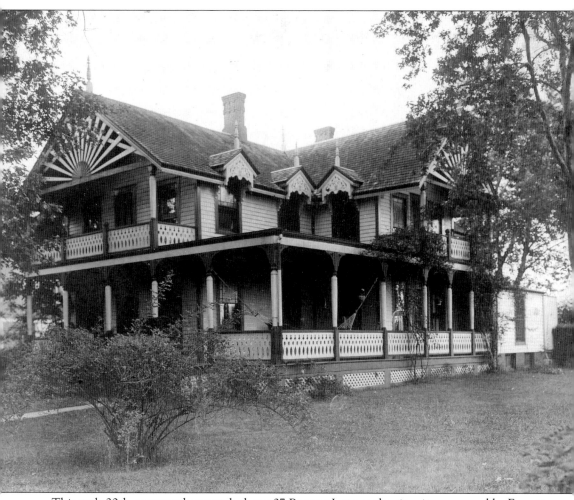

This early-20th-century photograph shows 27 Browns Lane at the time it was owned by Everett Price. He was a butcher by trade who was Bellport's first mayor and first foreman of the Bellport Hook and Ladder Company, which was founded in 1893 and became the Bellport Fire Department in 1905. The southern edge of the Price property was used to cut Price Street, connecting Browns Lane to Brewster Lane in the early 20th century. Even though this Carpenter Gothic–style house has lost its finials and the filigree detailing over the second-story windows that is seen here, the playful sunburst carvings under the gables and the pierced balustrades of its porches are still intact, making for an exuberance that enlivens the street. (Courtesy Forrest Meachen.)

Four of the five daughters of Mary and Everett Price pose in this photograph from about 1915. From left to right are Dorothy, Maude, Audrey, and Evelyn Price. Visible behind them to the left is their home at 27 Browns Lane. (Courtesy Forrest Meachen.)

This photograph from about 1949 shows Mary Price sitting on the steps of her home at 27 Browns Lane with her great-granddaughter Linda Meachen. Note the window behind them with the original colored glass, which is still intact today. (Courtesy Forrest Meachen.)

The oldest part of 41 Browns Lane is the south, shingled section. Built before 1858, it is one of the lane's earliest structures and belonged to a member of the Petty family until at least 1873 and later to the Raven family. The north part of the house was added probably in the 1870s. (Courtesy Robert Duckworth.)

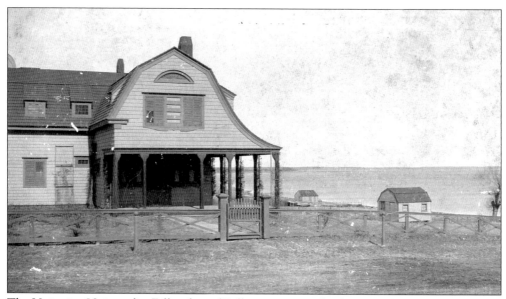

The Unitarian Universalist Fellowship of Bellport occupies this house at 51 Browns Lane, seen here when it was relatively new at the end of the 19th century. The perspective is from Browns Lane. The land on which this Dutch Colonial stands once belonged to Capt. Joseph Marvin, and the house was built for W. T. Walton and later purchased by Charles E. Bedford and others. (Courtesy Bellport-Brookhaven Historical Society.)

Five

ACADEMY LANE

Academy Avenue (Academy Lane) was created by 1833, the time when the Bellport Classical Institute, or academy, was built. Capt. Thomas Bell laid out Front Street (Shore Road) to run east at its southern terminus and added perpendicular Bell Avenue, perhaps as a shortcut to school for students boarding at the Bell House on Bellport Avenue. For a time, Academy Lane was called Osborn Avenue. Bell Avenue had various names, including Academy Lane, Maiden Lane, School Street, and today's misspelled Osborne Street.

The development of Academy Lane was influenced by three elements: the old golf course, the subdivision of Bellport Lane properties, and the academy itself. By 1900, 11 houses, several barns, the academy, a jail, a cemetery, a blacksmith's shop, and a clubhouse on a nine-hole golf course stood on Academy Lane. In the early 20th century, a few Bellport Lane properties were subdivided, creating new lots on Academy Lane. The golf course closed in 1916 and was subdivided with the rest of the land on the west side of the street. Only four homes, 40, 27, 23, and 20 Academy Lane (a 19th-century house that was moved to its site), were built on these lots before World War II. The others were built upon after the war, which was the same period when almost all the rest of the Bellport Lane properties were subdivided. This was the era of ranches and capes, and these define almost half the buildings on Academy Lane.

Today there are 28 homes in the Academy Lane Historic District, which was created in 2005; 15 of them are old, 12 are 19th-century structures, and 3 date from the first quarter of the 20th century. Thirteen homes are post–World War II. Of the 19th-century homes, five were built as dwellings and are in their original locations, including those at 10, 14, 18, 16, and 37 Academy Lane. The structure at 21 Academy Lane was built as a carpentry shop, and 11 Academy Lane was a blacksmith shop. The academy, at 24 Academy Lane, was converted into a home in 1919 after being moved twice. The clubhouse was relocated north to a flag lot at 12 Academy Lane. The building at 20 Academy Lane was moved to its present site from a nearby location after 1900. Two 19th-century barns became 25 Academy Lane and 29 Academy Lane.

The importance of scale is manifest on Academy Lane. Its antique and modern houses, sizable and small, blend together in a respectful celebration of a wonderfully narrow streetscape.

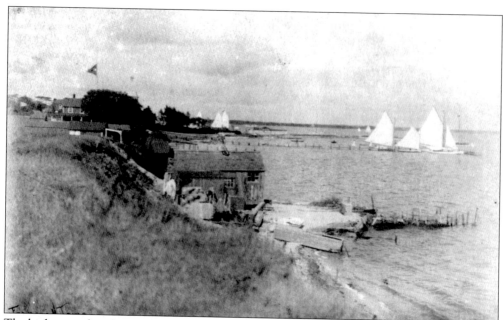

The high ground to the west of Bellport Lane, once known as Osborn's Bluff, was a popular place for picnics and viewing regattas. The original golf course was located on the bluff, and a bathing beach with 60 bathhouses, built by Robinson and Watkins, was at its bottom. Ashcan School artist William Glackens found that positions on the bluff or at its base offered excellent vantage points from which to paint. The image above, photographed by Frances Toms at the western extremity of the old golf course, shows the clubhouse at the far left, Wilbur Corwin's shack in the center, and a bathhouse behind it. The image below shows the rise from the water level with three figures. The bathhouses were further east and are not pictured. The Bay House Hotel is in the distance. (Courtesy Bellport-Brookhaven Historical Society.)

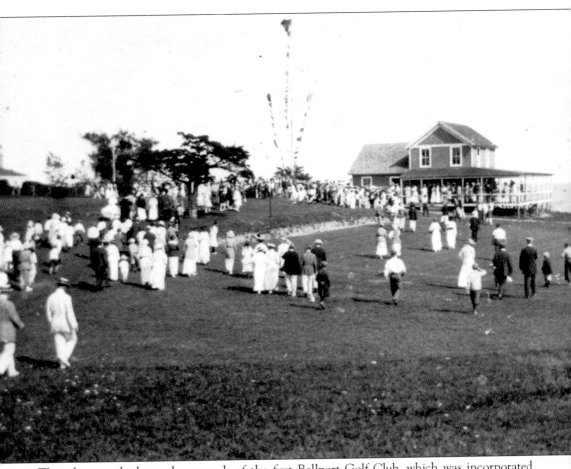

This photograph shows the grounds of the first Bellport Golf Club, which was incorporated in 1899 and located west of Academy Lane. The clubhouse, used also for the yacht club after 1906, is where 40 Academy Lane stands today. To the left is 2 Shore Road. This picture was taken around 1909, and the crowd is gathering along the shore to view the regatta. (Courtesy Bellport-Brookhaven Historical Society.)

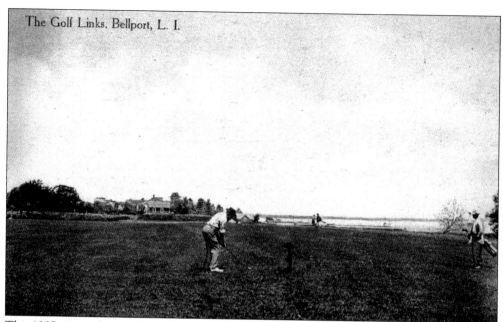

The Golf Links, Bellport, L. I.

This 1907 postcard views the golf course from the west. After 1921, when the new yacht club was built on the dock at the foot of Bellport Lane, the clubhouse, seen left of center with the Bay House Hotel tower beyond, was moved away from the water and today is a private home situated on a flag lot at 12 Academy Lane. (Courtesy Bellport-Brookhaven Historical Society.)

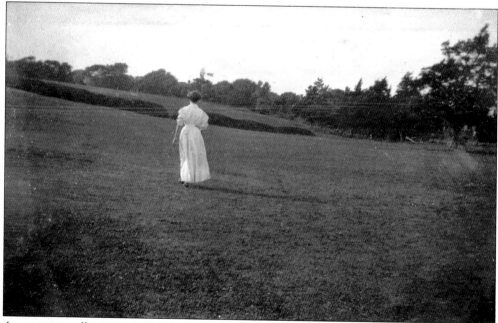

A woman is walking on the green near Academy Lane in the summer of 1907. On the horizon is a windmill, one of many that dotted the landscape of Bellport. In 1916, the golf course closed and the land was subdivided into building lots. (Courtesy Bellport-Brookhaven Historical Society.)

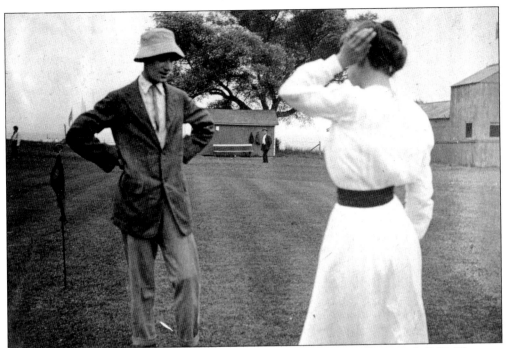

On the golf course, Corrine Baldwin is speaking with Bernard Tills around 1907. They are standing slightly west of the clubhouse, just about where Rogers Avenue is today. The caddy house and caddy are in the center, and a barn is on the right. (Courtesy Paige family.)

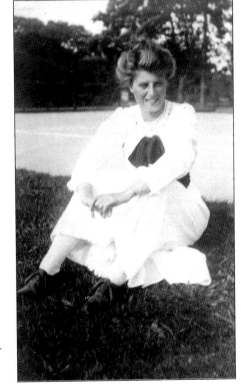

Baldwin relaxes near the tennis court in this photograph from about 1907. She is not far from the carriage house for 46 Bellport Lane that would be moved west to a new adjacent lot in 1951 and become 29 Academy Lane. She is also not far from a barn owned by the Petty family that would be transformed as part of the arts-and-crafts-influenced building at 23 Academy Lane. (Courtesy Paige family.)

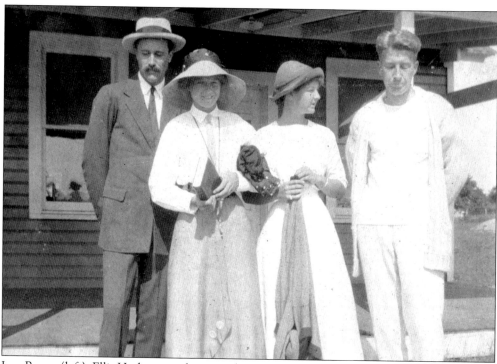

Lou Buzzer (left), Ellis Huthryn, and two unidentified female companions are standing near the veranda of the clubhouse around 1910. William Glackens included the clubhouse in some of his paintings of Bellport. This picture is the only photograph extant to show the original yacht club up close. (Courtesy Paige family.)

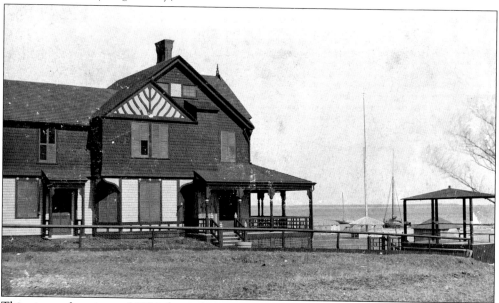

This picture from around 1900 shows the western facade of 2 Shore Road when the golf course was adjacent. The foreground is about where Glackens painted two of his pictures in 1913, *Beachside* and *The Captain's Pier*. Not seen is the sleeping house or guesthouse across the street at 37 Academy Lane called the "flower box." (Courtesy Bellport-Brookhaven Historical Society.)

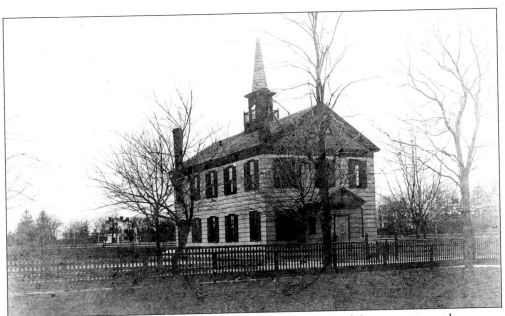

This photograph from about 1900 shows the Bellport Classical Institute, or academy, as a public school at its original location. It was about to become obsolete when the Union Free School District was formed in 1901 and a new building was built on Railroad Avenue (Station Road). Behind the academy is the *c.* 1835 Henry Weeks Titus house that was, at the time of the photograph, the residence of Frederick and Birdsall Otis Edey. (Courtesy Bellport-Brookhaven Historical Society.)

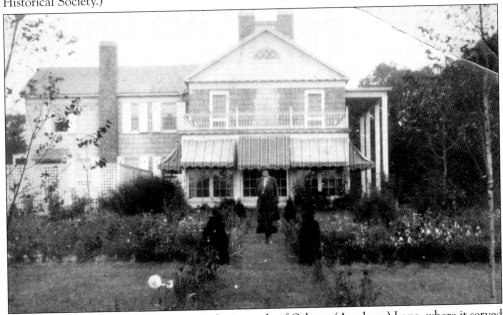

The academy was moved twice, first to the east side of Osborn (Academy) Lane, where it served as a carpentry shop, and then, after being purchased by Dr. T. Mortimer Lloyd, it was moved back to the west side of the street and south, where it was remodeled into a home by artist Walter Granville Smith. Pictured is Anne Lloyd in her garden beside her new home after 1919. (Courtesy John Everitt.)

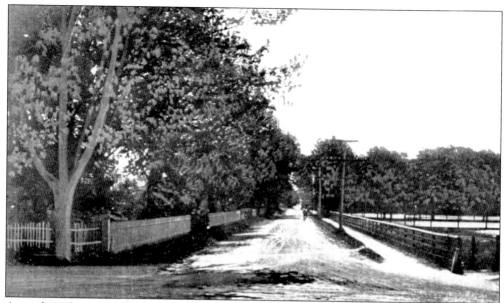

An early-20th-century view of Academy Lane looking south from South Country Road is shown on this postcard. After 1901, tennis courts replaced the academy when it was moved to the east side of the street. The fence enclosing 6 Academy Lane today, where the academy had stood, is remarkably similar to the one seen in this postcard on the right. (Courtesy Bellport-Brookhaven Historical Society.)

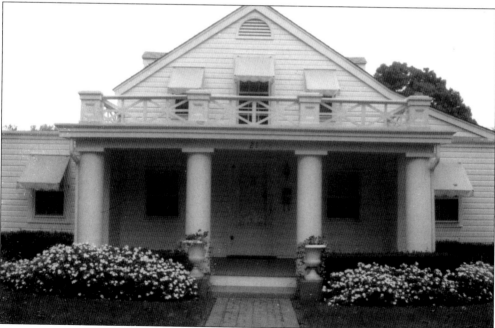

The structure at 21 Academy Lane is distinguished by prominent Greek Revival embellishments. It was built before 1850 as a carpentry shop at one of the Petty family's Bellport Lane properties. Boats and decoys were probably made there. As shipbuilding in Bellport declined, the building was sold off, resulting in the first subdivision of a Bellport Lane property. The famous painter of cats, John Henry Dolph, summered here from 1875 to 1903. (Courtesy Robert Duckworth.)

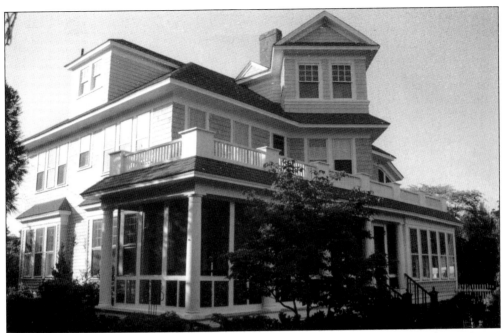

The building at 27 Academy Lane was built sometime in the first quarter of the 20th century on a plot created by the subdivision of the large property owned by Thomas Johnson on Bellport Lane. Next door, which is now 25 Academy Lane, was originally a barn on that property; a vestige of its barn days, a screened cupola, still sits proudly on its roof. (Courtesy Robert Duckworth.)

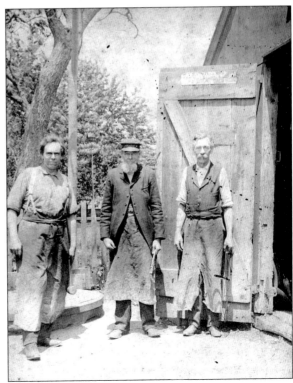

This late-19th-century photograph shows the Shaw family, who were blacksmiths, at their shop on Academy Lane. Charles K. Shaw is to the left, Joseph is in the center, and Joseph Jr. is on the right. Their specialty was the unique wrought iron hardware for the Bellport Gate that allowed them to "click delightfully," as Charles Hanson Towne described in his book, *Loafing Down Long Island*. (Courtesy Bellport-Brookhaven Historical Society.)

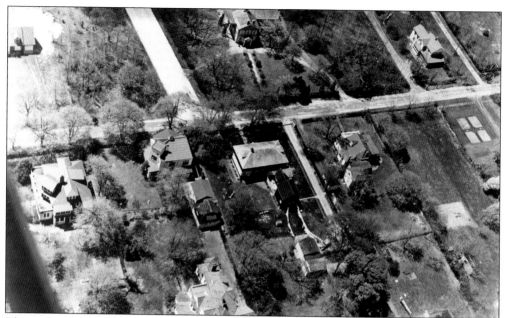

This 1950s aerial view shows Academy Lane across the top half of the photograph with the academy on the west side (top center) of the street. The empty lots were soon filled with iconic suburban ranches; 13 exist on the lane. As a group, these homes are remarkable because their cottage scale complements the intimacy of the neighborhood, contributing to its identity. (Courtesy Bellport-Brookhaven Historical Society.)

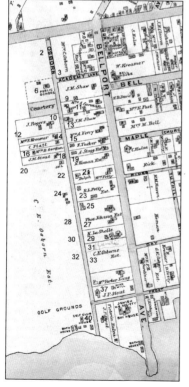

A detail of a Bellport Village map from about 1900 shows Osborn Lane (Academy Lane) superimposed with the location of the 28 homes in this historic district. The 19th-century structures built as homes and in their original locations are 10, 14, 18, 16, and 37 Academy Lane. Later the C. Platt house was probably moved southwest, becoming 20 Academy Lane, and the jail was moved to First Street. (Courtesy Bellport-Brookhaven Historical Society.)

Six

BEACH AND BAY

The Great South Bay is approximately 45 miles long and protected from the open ocean by the Great South Beach, or Fire Island. Bellport Bay has been described as the most interesting portion of the Great South Bay, because the land that borders it on three sides is the highest along the entire bay's shore and its four-mile width is the bay's narrowest. The resulting sweeping views and comforting breezes, together with the charming houses built by early residents and its proximity to New York City, made it inevitable that the village would mature into a desirable summer destination. "Beyond Patchogue is Bellport, an ideal summer resort commanding an excellent view of the Great South Bay," proclaimed a 1907 circular for the Long Island Rail Road. Entrepreneurs in the late 19th century capitalized on the village's propitious location on the bay, building hotels to accommodate visitors. Others with the means to build seasonal homes formed private clubs for golfing, swimming, and hunting. The social scene included the famous and the creative, but Bellport tended to cultivate a low profile and was described in George T. Sweeny's work, *Long Island: the Sunrise Homeland*, as "a summer home for families of those who wish quiet and aristocratic recreation".

At the end of the 19th century and beginning of the 20th century, people who had their own boats were addressed as "captain." Indeed, freelance captains could be hired for a sail to the ocean beach on Fire Island or around the bay. By 1914, regular ferry service to Fire Island began with the *Mildred A.* and the *Ruth*. The rich enjoyed their own boats, captains, and docks. If one preferred the ease of bathing in the calm waters of the bay close to the hotels, bathhouses were available by the shore. After the yacht club was formed in 1906, the Labor Day regatta became a big attraction. The recreation focused on the water but was not limited to the summer. When the weather turned cooler, the hunting season began on the bay bogs. If the bay froze, the fun continued with ice-skating and scootering—the winter sport developed on the bay using a Bellport invention, the iceboat or scooter.

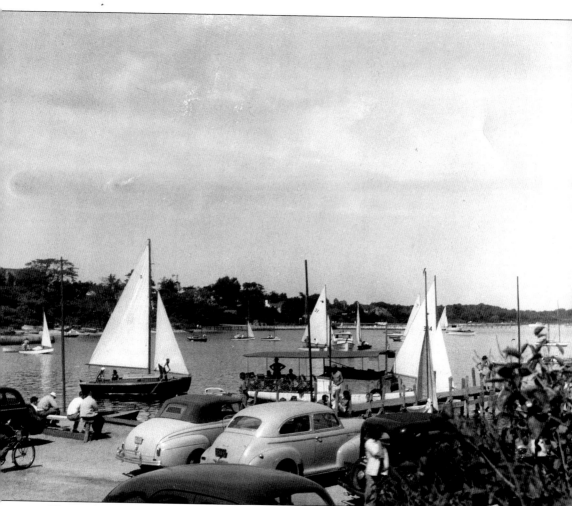

This early-1940s picture, taken at the Bellport Marina, shows the *Mildred A.*, one of the two boats that provided regular ferry service to Fire Island from 1914 to 1945, arriving from the Old Inlet Club beach. Ray Davis captained this ferry while Wilbur Corwin was the captain of the other ferry, the *Ruth*. The ferry dock and waiting area today are at the same locations as they were then, and except for the absence of additional piers extending from the main dock, the marina looks the same. Unlike many marinas on Long Island that have become so cluttered, the Bellport marina is a tutorial in simplicity, a platform from which to raise one's spirits. (Courtesy Judith Bianco.)

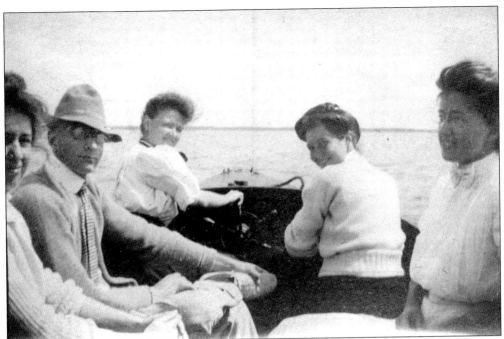

Florence Crowell is seated far right in this undated photograph. The others are unidentified. In 1967, Crowell deeded her property at 31 Bellport Lane to the historical society. It was the nucleus of the present museum complex. (Courtesy Bellport-Brookhaven Historical Society.)

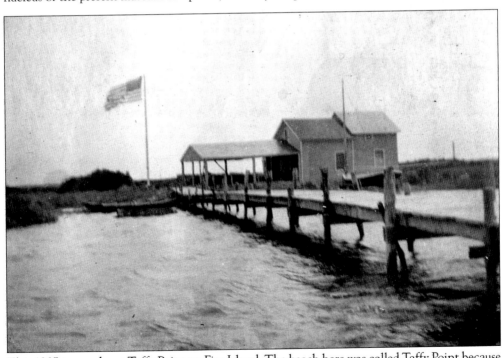

This 1907 image shows Taffy Point on Fire Island. The beach here was called Taffy Point because of the saltwater taffy made there by Carrie Hawkins. It eventually became the Old Inlet Club. (Courtesy Bellport-Brookhaven Historical Society.)

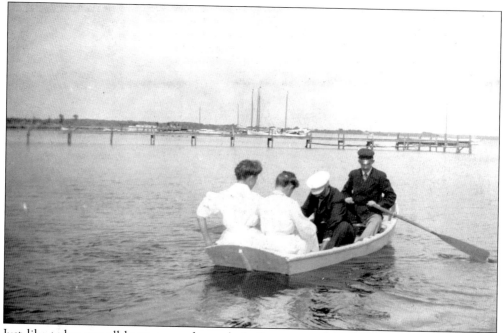

Just like today, not all boats moored at a dock. Boats at anchor were reached by dingy. This photograph from the dawn of the 20th century shows two women being rowed to a moored boat with their captains. At the time, anybody who operated a boat in Bellport was called a captain. (Courtesy Bellport-Brookhaven Historical Society.)

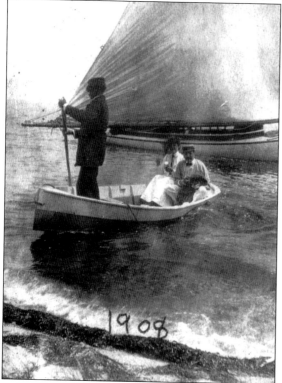

This 1908 photograph shows an unidentified couple being rowed back to shore by a captain after disembarking from the sailboat behind them. It is probable that they were guests at either the Wyandotte Hotel or the Goldthwaite Inn. (Courtesy Bellport-Brookhaven Historical Society.)

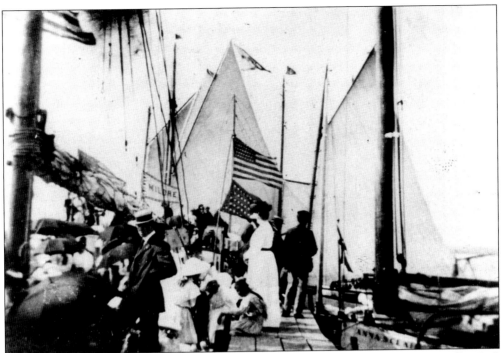

This picture from about 1912 shows boats moored at the yacht club dock on a regatta day. Left of center is a banner for the *Mildred A.* ferry, and under the U.S. flag is a navy jack, a blue flag containing a star for each state that is hoisted on a short mast, or jack staff, at the bow of a boat. (Courtesy Bellport-Brookhaven Historical Society.)

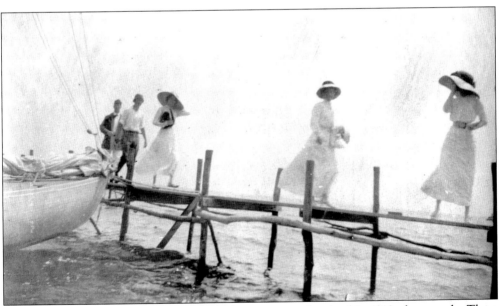

A group is arriving at the yacht club dock on regatta day in this 1913 photograph. These unidentified people are walking on a stick dock. Stick docks were fairly sturdy although they did not look so. They were removed from the water for the winter. (Courtesy Paige family.)

In this picture from about 1910, Maj. William H. Langley is sitting at the rear of his motorboat, and Auggie Hermansen is at the controls. They are at the private dock of Old Kentuck. In the background, left of center, is the outline of the residence, and to its right is its distinctive water tower. In its 1890 description of the estate, the *Brooklyn Eagle* reported that the windmill was

"as big as a house" and "situated at a distance to the northeast from it so as not to overwhelm it." It further recounted that it had an ample porch from where one climbed up a staircase to an observation balcony and furnished rooms. (Courtesy Dorothy Maggio.)

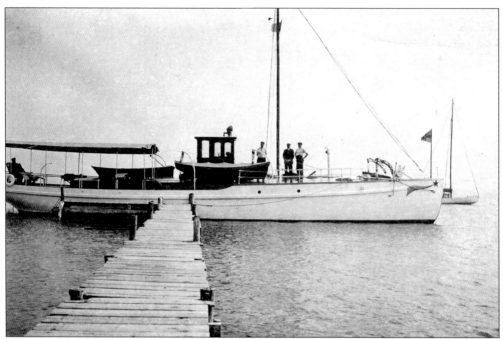

Pictured around 1910 is the *Comet*, Maj. William H. Langley's 75-foot yacht, with its crew at mid-ship and its owner at the stern. Capt. Charles Williamsen is at the controls, and his brother Henry stands by the mast. Augie Hermansen, the engineer, and Howard Houston, the cook, stand toward the bow. The *Comet* was often used as a committee boat in yacht club races from 1907 to 1918. (Courtesy Dorothy Maggio.)

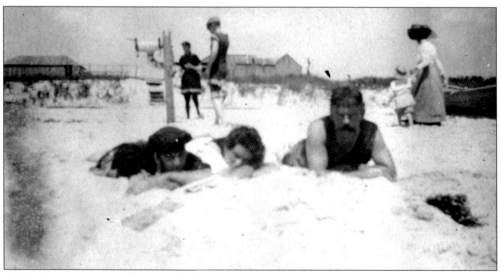

Old Inlet was a private beach club formed in the spring of 1910 with Darwin Meserole as its president and Paul Bigelow as its secretary. It was exclusive, and, as with many institutions in the country at the time, it discriminated against most ethnic groups, especially in its early decades. Lying in the sand in this photograph from about 1910 are friends of the Paige family. (Courtesy Paige family.)

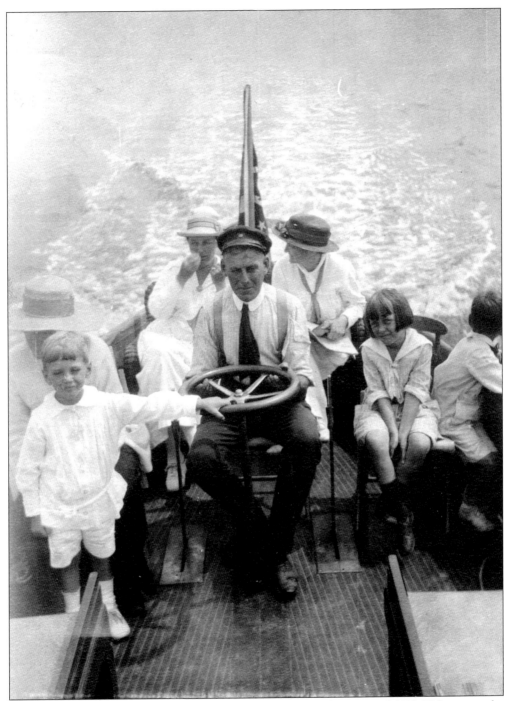

The neighbors of Langley, the Hoyt family, are enjoying their boat around 1910. Helping out the captain to the left is John Frank Hoyt Jr. Seated on the right is Harriet Hoyt with her brother James. The others are unidentified. In those days, family pleasure boats always had captains and often a crew. (Courtesy Bellport-Brookhaven Historical Society.)

John Frank Phillips married Harriett Hoyt in October 1907. They had four children, John Frank Jr., James, Robert, and Harriet; lived in Irvington, New York; and summered in Bellport. Pictured are John and Harriett on the Great South Beach, or Fire Island, soon after their marriage. (Courtesy Bellport-Brookhaven Historical Society.)

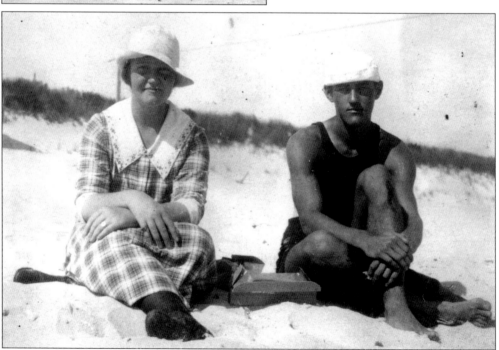

Pictured on Fire Island is Ethyl Kreamer Quinn with an unidentified lifeguard around 1905. Quinn was the daughter of George Kreamer, who worked at the Bell House and later owned the Wyandotte Hotel. (Courtesy Jean Steele.)

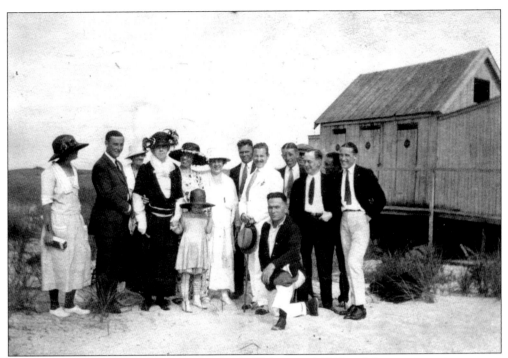

Lucy Mott is seen here at the Old Inlet Beach Club around 1919 with her recuperating veteran guests and others. Up to 30 men stayed at her estate for the summer. (Courtesy Jean Steele.)

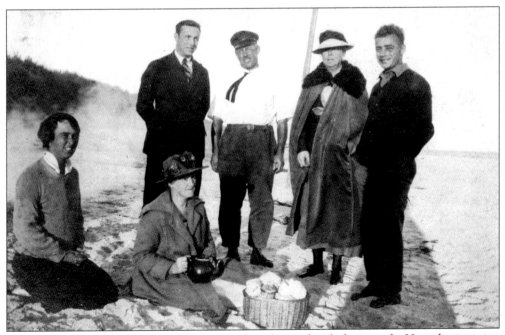

Mott held a tea at the beach, as documented in this undated photograph. Here she is sitting and holding a teapot. Standing behind her is Jack Quinn, a veteran guest, and next to him is Will Corwin, who captained her boat to Fire Island. The others are unidentified. (Courtesy Jean Steele.)

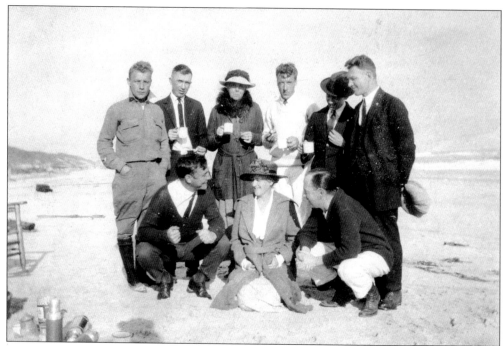

Lucy Mott is sitting in the center while her friends sip tea behind her. To her right is Jack Quinn. For a time, Quinn escorted Mott to Wyandotte Hotel parties, where he met Ethyl Kreamer, the owner's daughter, who was in Bellport for the summer from Smith College. Quinn and Kreamer got married at Christ Episcopal Church the following December. The marriage was short-lived. (Courtesy Jean Steele.)

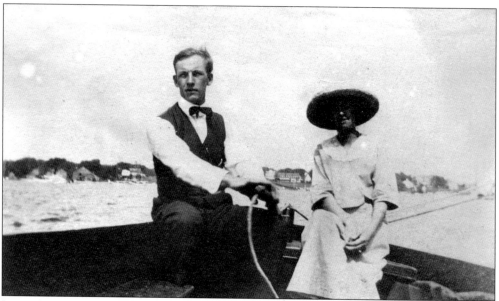

Isaac Smith and his wife enjoy a sail on the bay in this 1913 photograph. Visible on the shore between them is the Wyandotte Hotel. They are the parents of Eva Smith, who inherited one of the most important houses in Bellport from them. It was torn down in 1989 after her death. (Courtesy Al Sakaris.)

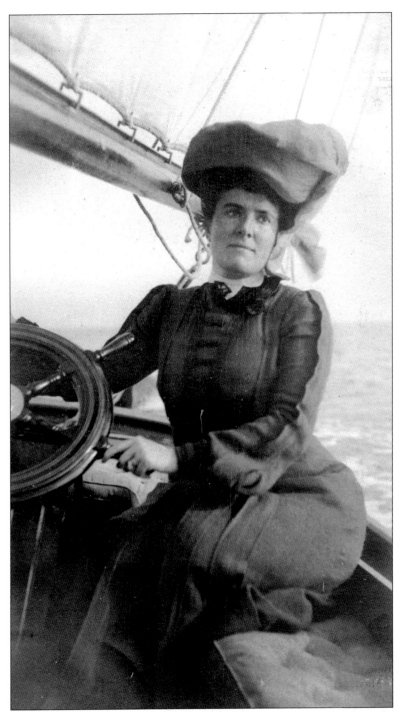

This photograph from about 1900 shows Anne Lloyd sailing on the Great South Bay. Lloyd was a good friend of Birdsall Otis Edey and was involved in the suffrage movement and prison reform. She also wrote poetry and prose that were published in the *New Yorker*. Until her death in 1949, her Bellport home was the academy, where she had a writing studio called "the Temple." (Courtesy John Everitt.)

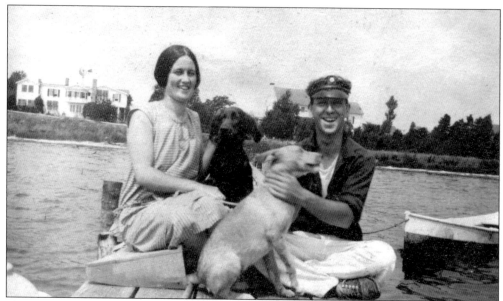

Eleanor "Billie" Cromwell Field and Theodore Trail Everitt are on a dock at Howells Point Cove in the 1920s. Howells Point Cove is near Thornhedge Road and Otis Lane. They were married soon after the photograph was taken. Field was the daughter of Anne Lloyd, owner of the academy; Everitt's family lived on South Howells Point Road at See the Sea. Behind them to the left is the house that belonged to Commodore Paul Bigelow. (Courtesy John Everitt.)

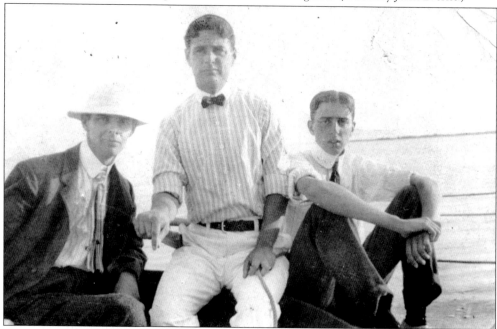

From left to right, this undated photograph shows George Parker Lyman, Francis Marion Lyman, and James Otis Lyman sailing their grandfather's boat, the *Walloping Window Blind*, in Bellport Bay. The fourth brother, Harrison Gray Lyman, probably took the picture. These young men lost their father when they were very young and were brought up by their mother and grandparents at Woodacres in East Patchougue. (Courtesy Gray Lyman.)

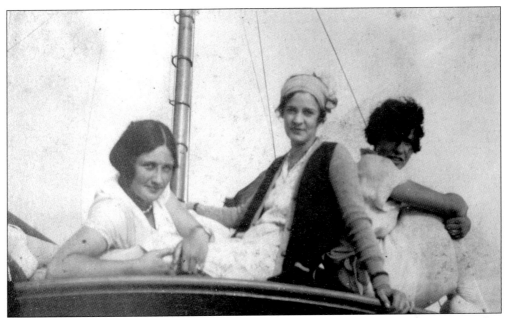

On board the *Pelican* in the 1920s, from left to right, are Field, Happy Bedford, who lived at 51 Browns Lane, and an unidentified person. The *Pelican*, named after a bay island, was a shoal draft sailboat built in 1910 by Gil Smith of Patchogue for his own use. It was acquired by the Everitts in 1921. Like all of Smith's boats, it had great speed and beauty. (Courtesy John Everitt.)

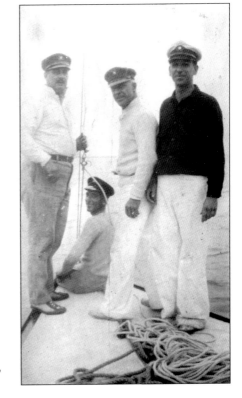

These four sailors are on the *Pelican* in the early 1930s. From left to right, they are Gertin Tuttle, Frederick Gurney, Charles Holbrook, and Everitt. The *Pelican* was the smallest of the P-class boats. The other P-class boats active on Bellport Bay in the late 1920s were the *Alva, Bee, Eskawaja, Elvira, Kid,* and *Constance.* (Courtesy John Everitt.)

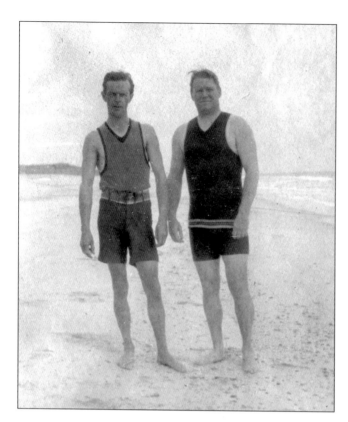

On the beach at Old Inlet is Ashcan School artist Everett Shinn on the left with Dwight. They are wearing the typical swimwear for men of the period. The Old Inlet Club closed in the early 1970s and was replaced by village-owned Ho Hum Beach to its west. Ferry service to the new ocean beach was provided by the *Leja Beach*. (Courtesy Paige family.)

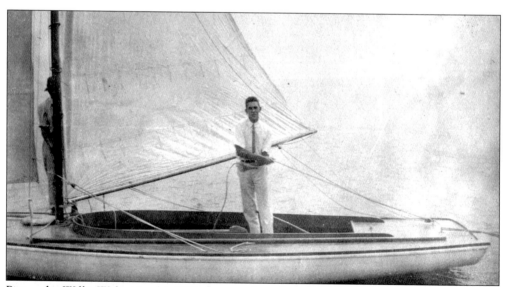

Pictured is Willie Walton in this 1910 photograph on board a Bellport Bay sloop called the *Lady J. T. B.* Walton was seen in a previous picture as a little boy in a goat cart at the Wyandotte Hotel. (Courtesy Paige family.)

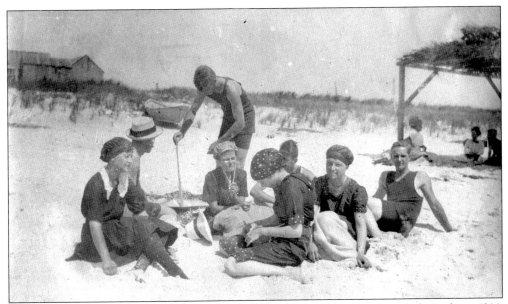

The Edeys and the Paiges enjoy Old Inlet Beach together in this photograph from about 1914. The women's bathing suits resemble dresses and were made of wool. The men's suits seem more modern. Among those seen here are Louise, Ellis, Rausom, Little Rich, Kathryn, Burt, Corinne Baldwin, and Gerrit. A dock and boardwalk are all that remain today of the Old Inlet Club. (Courtesy Paige family.)

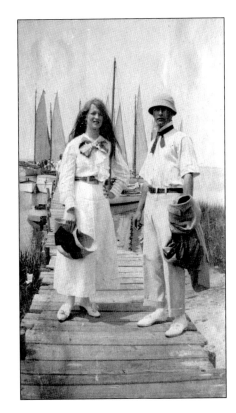

Standing on the dock of the Old Inlet Club in this undated photograph is Everett Shinn with a friend. Shinn and his wife, Florence Scovel Shinn, were good friends of William Glackens and visited him frequently in his rented Bellport home at 28 Bellport Lane. (Courtesy Paige family.)

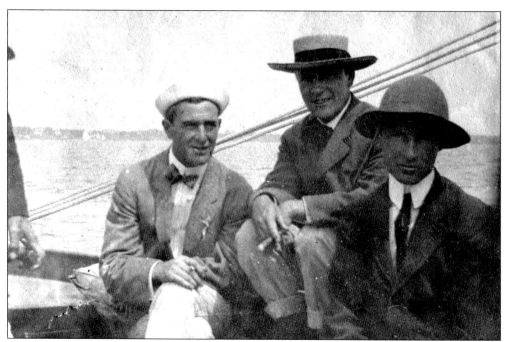

This undated photograph shows artists of the Ashcan School sailing on the bay. From left to right are Max Strakosch, William Glackens, and James Preston. Glackens spent five summers in Bellport starting in 1911 and one summer in Brookhaven Hamlet. His friend and collector, Albert Barnes was in nearby Blue Point. By 1922, Barnes organized his famous foundation in Merrion, Pennsylvania, where the collection features several of the 17 pictures painted by Glackens in Bellport. (Courtesy Paige family.)

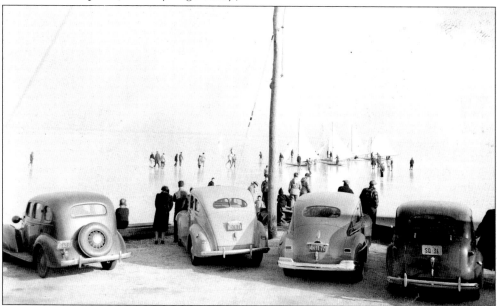

The frozen bay with scooters and skaters is depicted in this 1940s photograph. One can look at similar photographs from decades earlier or later, and this classic Bellport scene remains the same. Change is only manifested in fashion and technology. (Courtesy Paige family.)

Nine

ON THE ROAD
TO PATCHOGUE

Bellport Village is at the heart of the three communities that lie on the old South Road, today known as South Country Road. To the east is Brookhaven Hamlet, examined in the first volume. To the west lies East Patchogue, a place at once suburban and rural, stamped with the imagination of the family that created it. For generations the Robinson family influenced the development of East Patchogue through its extensive ownership of land. They envisioned an independent, exclusive community, separate from the surrounding communities.

The Robinsons' ownership of East Patchogue is traced back to before 1800, when two brothers, Joseph and Phineas Robinson, acquired land that William Smith had purchased by lottery in 1756 from Humphrey Avery. What the brothers procured were two necks of land, Francis and Moger's, which were described in a legal document known as the Winthrop Patent. Two other necks, Pine and Swan River, were conveyed to Humphrey Avery Jr. These four necks became East Patchogue.

In the 19th century, East Patchogue prospered with the same economy shared by similar developing communities in Brookhaven. But unlike its immediate neighbors, prosperity in East Patchogue did not translate into a collective sense of identity. Instead identity remained fragmented among large landholding families such as the Robinsons. As the century progressed and the economy changed, it became clear that ownership of land alone was not enough to maintain an exclusive identity or provide a sense of community. East Patchogue became a neighborhood lacking direction. To secure public services, the Village of Patchogue incorporated in 1893, followed by the Village of Bellport in 1908. East Patchogue did not incorporate and was soon forced to turn to these communities for the services it required. The population declined, and farmland was sold off for quick profit. In the 1930s, huge estates owned by the wealthy, such as the Lymans, Durkees, and Litts, were abandoned or sold, subdivided, and transformed into middle-class nirvanas with names such as Patchogue Shores and South Country Shores.

Despite what it has gone through, East Patchogue still possesses great charm and beauty. For generations, it has been home to large nurseries. An 1874 historical sketch described South Country Road "as a delightful road to drive over." The same is true today. The geography affords lovely vistas, and the many old houses lend quiet distinction.

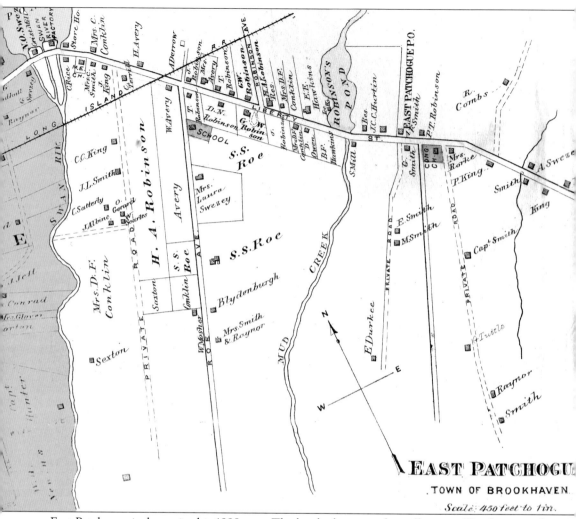

EAST PATCHOGUE
.TOWN OF BROOKHAVEN.
Scale: 450 feet to 1 in.

East Patchogue is shown in this 1888 map. The border between the mill town of Patchogue and the community of East Patchogue was the Swan River, which flowed south from the upper pond just north of Main Street. The upper pond was one of the two beautiful ponds of the area. The gristmill is noted on the Patchogue side of the pond. To the east is the lower pond, or Robinsons Pond. South of Liberty Street (South Country Road), on the east bank of Mud Creek, is the sawmill built by the Robinsons and torn down in 1912. The first Robinsons who settled East Patchogue established themselves near this pond. Phineas was on the east side, and his brother Joseph was on the west side. The last of the Robinsons to live in East Patchogue, Gertrude Robinson Bianchi grew up on a rise just southwest of the pond at 160 South Country Road. Besides the Robinsons, the names of other large property owners appear on this map. In the 20th century, East Patchogue was no longer the distinct community envisioned by its founders. (Courtesy Bellport-Brookhaven Historical Society.)

Humphrey R. Avery, son of the founder of Swan River Nursery, is walking his bike in front of his extended family's home at 29 South Country Road. This Queen Anne house, built in the 1880s on Swezey Street, was moved in 1901 by his father to its current location. Avery, the last male in the family, studied at Massachusetts Agricultural College before formally entering the family business as a manager in 1920. (Courtesy Barbara Avery.)

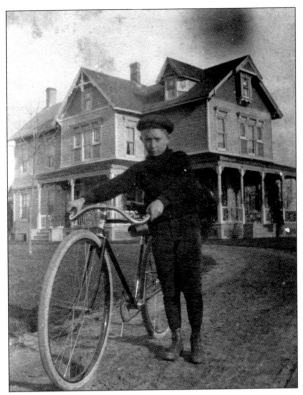

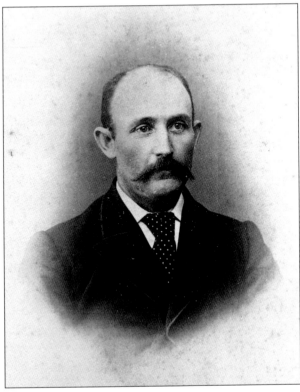

Charles W. Avery was born in 1854 in the old homestead and married Grace A. Lane of Mattituck. He was a farmer, dairyman, and nurseryman and was involved in real estate. He laid out Avery and Washington Avenues in Patchogue and founded Swan River Nursery in 1898. He died in 1915. (Courtesy Barbara Avery.)

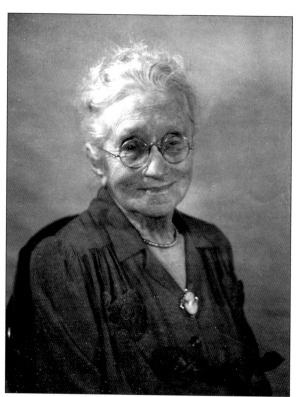

Grace Adele Lane Avery, Charles W. Avery's wife, is pictured here when she was 90 years old. When her husband died in 1913, she managed the business and helped train her son Humphrey to operate it. (Courtesy Barbara Avery.)

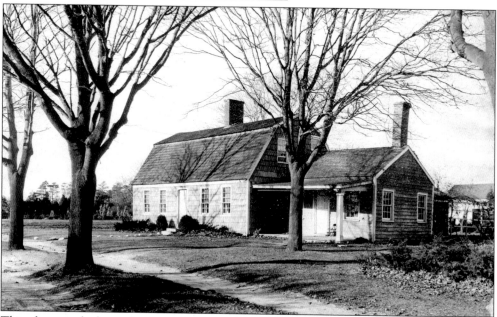

This photograph shows the Avery homestead at 39 South Country Road before it was moved back from the road in 1926 and used as a sales office for Swan River Nursery. John Avery built the house in 1820, and his son, grandson, and great-grandson were born there or lived there. For generations, the Avery family has referred to this shingled, gambrel-roofed structure as the 1820 house. (Courtesy Barbara Avery.)

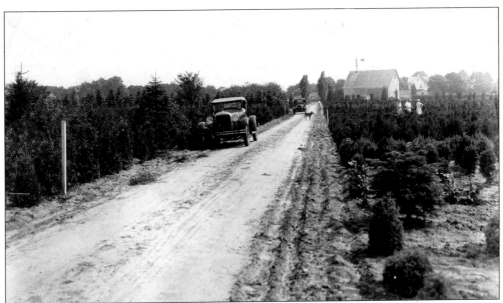

Swan River Nursery consisted of approximately 100 acres, spreading north and south from where the Avery homes are today. The business included growing all kinds of nursery stock and was one of the largest enterprises of its kind on Long Island, holding the leading rank in its field in the East. The perspective in the 1918 photograph above is south. Today the Montauk Highway and shopping centers occupy the land. At the far end of the road, the 1820 house is in sight and the Victorian house is to the right. The original barn on the property, with a weather vane on its roof, is between them. The present Avery property consists of 10 acres. The photograph below from the 1920s shows plants loaded on a nursery truck sitting by the original barn. (Courtesy Barbara Avery.)

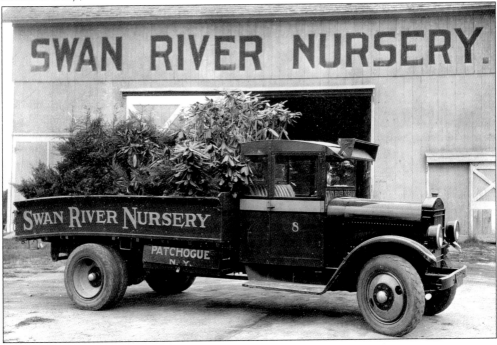

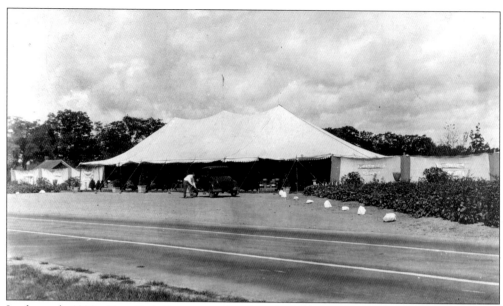

In the early 1920s, New York State capitulated to the lobbying effort of local residents led by Birdsall Otis Edey and built a spur of the Montauk Highway north of East Patchogue, Bellport, and Brookhaven Hamlet, thus bypassing these communities and protecting them from commercial sprawl. The spur, built partially on Avery land, was an opportunity for Swan River Nursery. Humphrey R. Avery opened a sales department in a tent on the north side of the new highway that divided his land and constructed a large fountain on the opposite side to further attract the public. The tent is shown above in this 1920s photograph. It was replaced later with a permanent building that was torn down for a shopping center in 1983. Seen below, the fountain, on the south side of the highway, is still there but is hardly visible because of the overgrowth. (Courtesy Barbara Avery.)

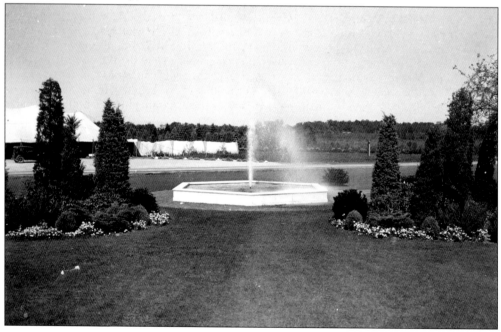

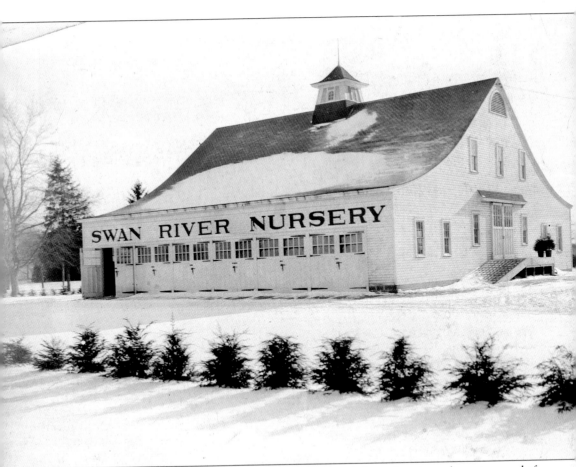

Pictured in this 1930s photograph is the Dutch Colonial–style barn that sits at the eastern end of the Avery property and is visible from South Country Road only in winter, an apparition when trees are bare. This structure was built in the early 1930s by Robert Woodhull and originally was home to the workhorses of the nursery. Mules and horses were used in the 1930s and 1940s when the area to be plowed was too narrow for a tractor to go through. The horses had names such as Dan and Tom, and their names are still visible in the stalls of this building. In the mid-1980s, its owner started and continues to raise miniature horses there, naming her business Peppermint Stik Farm. (Courtesy Barbara Avery.)

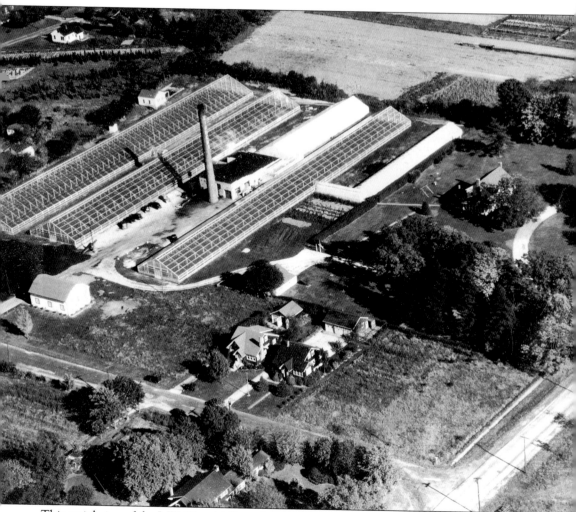

This aerial view of the I. W. Bianchi Greenhouses was taken in 1944. The 300,000 square feet of greenhouses were heated with coal at the time, and at the middle left of the picture, a pile of the coal and the smokestack can be seen. The 1923 Bianchi residence at 547 South Country Road is at the middle right. The business traces its start to Bianchi's employment at the Hiscox Nursery next door. Eben Hiscox, his brother-in-law, started his nursery in 1915 just west of this property. After obtaining a loan from his father, Bianchi decided to start his own business in 1928. Bianchi began with roses at the seven-acre nursery, and by the 1940s, he was also producing gardenias, camellias, stephanotis, and orchids. In 1973, the greenhouses created a new cymbidium orchid. The new hybrid was developed over a period of seven years and was registered with the Royal Horticultural Society in London. The primarily yellow bloom was named the Patchogue. The business closed in 1988, as the nursery business on Long Island declined in the global economy. (Courtesy William Bianchi.)

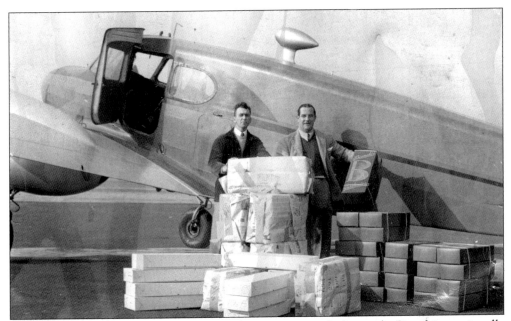

While most of the deliveries for the greenhouses were made by truck, Bianchi occasionally utilized airplanes. This 1949 picture shows Bianchi, right, with a planeload of roses destined for Providence, Rhode Island. He is with his pilot, Tom Simmons, at Davis Field in Bayport. Later Bianchi shipped his exclusive cymbidium orchids all over the world. (Courtesy William Bianchi.)

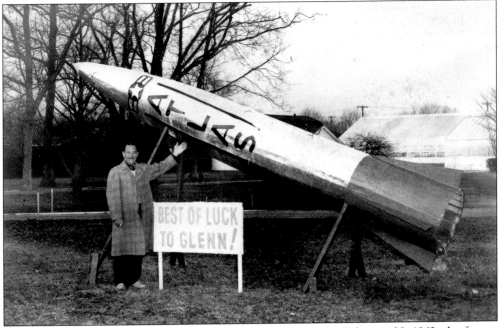

I. W. Bianchi Sr. was enthusiastic about the space program. On February 20, 1962, the former boxer and Patchogue's well-known orchid man commemorated astronaut John Glenn's trip into space by having a copy of the Atlas rocket built and displayed on his property. (Courtesy William Bianchi.)

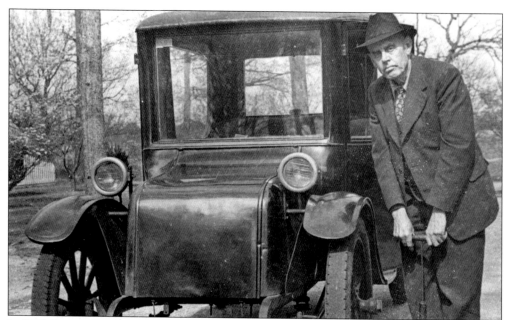

In 1915, Eugene Hawkins, owner of this electric car and Patchogue Electric Light Company, lived at 201 South Country Road, adjacent to Robinson's Pond. His neighborhood was described in 1921 as follows: "Between Patchogue and Bellport there is a road that dips and turns, with here and there a bridge to break the monotony of one's walk and glimpses of pools and streams to add delight to what is a charming province." (Courtesy Town of Brookhaven Historian's Collection.)

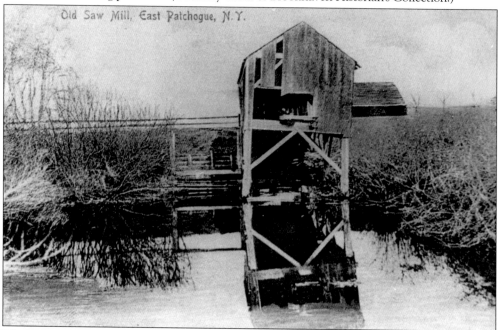

The Robinsons constructed a sawmill south of the country road to cut timber into cordwood destined for New York City brickyards. Cordwood was the fuel used in curing bricks. This postcard shows the mill around 1900. It was torn down in 1912. (Courtesy Town of Brookhaven Historian's Collection.)

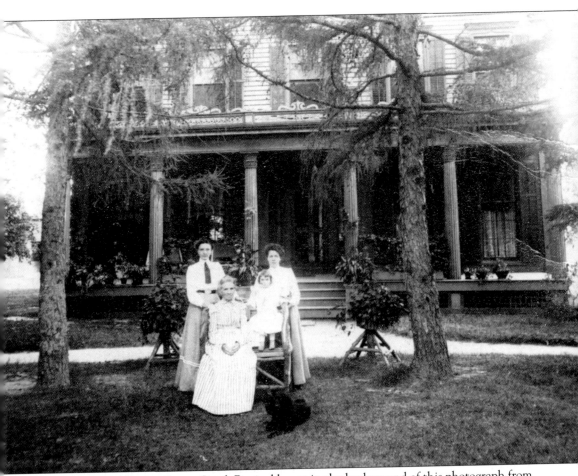

The architecturally significant Greek Revival house in the background of this photograph from about 1900 is a superb example of fine domestic architecture on Long Island. It is situated at 350 South Country Road and was built in 1837 by Capt. William Smith Jr., a successful sea captain who became a gentleman farmer and married Abigail Robinson. It was acquired by Charles Rourke in 1864 and inherited by his daughters, Cornelia and Mini Rourke (standing) of Brooklyn, who used it as a summer residence. The house, originally on 112 acres, is an important example of its type, displaying restrained massing and splendid details, including a light Gothic touch under the dentil-decorated lintels over each window. While the carved, full-width frieze above the porch is gone, the splendor of this building is undiminished. Especially noted for its distinctive cupola, Temple of the Winds capitals on the porch columns, and elaborate paneled front door, the house is an imposing presence in East Patchogue and an irreplaceable anchor to its past. (Courtesy Robert Duckworth.)

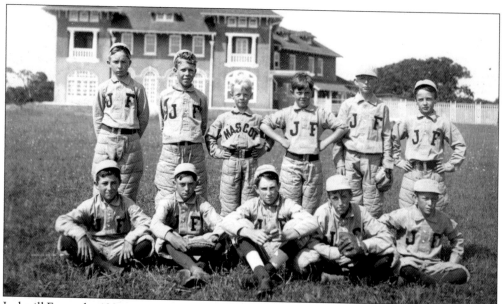

Jackwill Farm, the 120-acre property of Ruth Litt, was named for her two sons, Jack and Willard. Litt, a politically active woman and the founder of Patchogue's Christian Science Church, maintained a summer camp for boys at her estate. The baseball team included, from left to right in the back row, Humphrey R. Avery, Richard Smith, Willard Litt, Jack Litt, Roy Smith, and Norman King. The former estate became Patchogue Shores in the 1950s. (Courtesy Town of Brookhaven Historian's Collection.)

An undated photograph of the upper pond, or Swan River Pond, at the border between East Patchogue and Patchogue Village, shows the gristmill in the distance that once stood on its banks. G. G. Swezey was the proprietor of the mill that was built around 1840 by Austin and John Roe. (Courtesy Bellport-Brookhaven Historical Society.)

The Swezey family home, built in 1929 at 39 Roe Avenue, is shown in this 1940s photograph. This Colonial-style home, designed by architect Harry Aspenwell, is about a quarter mile north from Roe Farm on the same street. Pictured from left to right are Eva Pelletreau, Carroll Swezey, and Henrietta Swezey. The Swezey retail business began in 1894 when Arthur Swezey, an East Patchogue native, purchased two dry goods stores from A. Fishel and Company, one in Patchogue and one in Huntington. Swezey's success was built on the firm's integrity and reliability; his motto was "store on the corner with dealings on the square." (Courtesy Priscilla Swezey Knapp.)

This undated photograph shows East Patchogue's first post office at 322 South Country Road, established in 1907. It was also a general store and today is the home of Swan Realty. The first postmaster, Augustus Floyd Smith, had journeyed to Washington to successfully petition for official recognition of East Patchogue. Smith is recognized as Suffolk's ice-cream baron, who started making commercial ice cream in 1879 and built a business that was sold to the Reid Ice Cream Corporation of Blue Point in 1926 and later to the Borden Company. (Courtesy Peter Berman.)

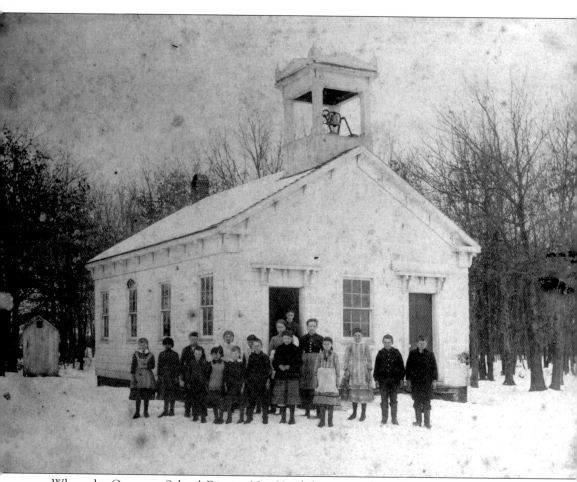

When the Common School District No. 39 of the town of Brookhaven was established on May 11, 1857, a school building needed to be built. The sole trustee for the school district, Norton Robinson, purchased land on the east side of Pine Neck Road (Roe Avenue) the following August from Stephen and Huldah S. Roe for $25. The one-room schoolhouse was soon built and maintained by a rate system that charged parents by the number of children enrolled. In 1867, the rate system was abolished. The building eventually became a bus pick-up station for students in the Patchogue School District. This 1880s photograph shows unidentified children in front of the school. Among locally known children attending class here were Irene and Humphrey R. Avery. Humphrey even managed to carve his initials on a desk, and they are still visible. In 1962, the Patchogue School District sold the building to the Town of Brookhaven for the purpose of establishing a museum that one can visit today at Roe Avenue just south of South Country Road. (Courtesy Barbara Avery.)

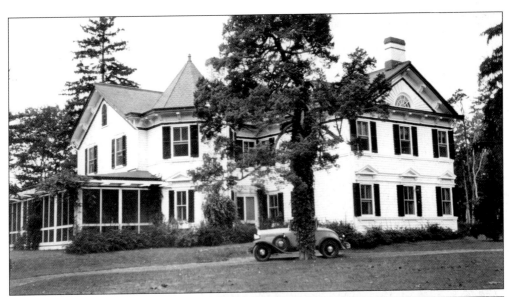

The residence at Woodacres in East Patchogue is pictured here in the late 1920s. George T. Lyman and Sally Otis Lyman built the estate on a cornfield around 1870 after their children had grown and used it as a summer home. The house, still standing, incorporates the original farmhouse that was on the property and blends stylistic elements of the Federal, Queen Anne, and Italianate styles. The Lymans (right) sold their estate to Bernard Baruch, who, in 1916, helped establish the new Bellport golf course with Frederick Edey. The course, designed by Seth Raynor on the former Locusts estate property next door, had room for only 16 holes. Baruch donated part of his estate to provide for a complete 18-hole course. (Courtesy Gray Lyman.)

Sitting on a porch at Woodacres is Millie Parker Lyman in the summer of 1891. She had married Gray Lyman, one of the sons of George and Sally Lyman, and lived for a while with her husband and four sons in the West while Gray was chief engineer for the construction of the Atcheson, Topeka and Santa Fe Railroad. When the railroad was completed about 1883, Gray died of yellow fever at age 34 before returning to the East. Millie and her sons went to live with the boys' grandparents at Woodacres. Two of her sons died in their youth while traveling. Millie buried them "near her" at Woodlawn Cemetery in Bellport, where she in turn would be buried. (Courtesy Gray Lyman.)

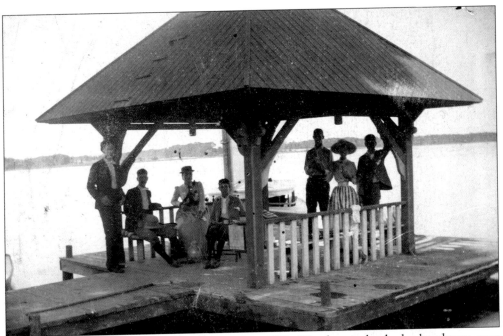

The sheltered dock at Woodacres is pictured in 1890. Woodacres also had a boathouse near the dock that survived until Hurricane Gloria swept it away in 1985. Pictured from left to right are unidentified, George P. Lyman, Mary Appleton, James O. Lyman, unidentified, Henrietta McLean, and Frank M. Lyman. (Courtesy Gray Lyman.)

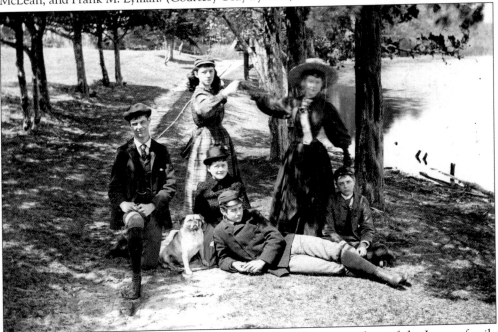

Posing for a picture at Robinson's Pond in the early 1890s are members of the Lyman family and their friends. From left to right are George P. Lyman, Totty Post, Frank M. Lyman, and Harrison G. Lyman. Standing are Natalie (left) and Henrietta McLean. The dog, Toots, belonged to Frank. (Courtesy Gray Lyman.)

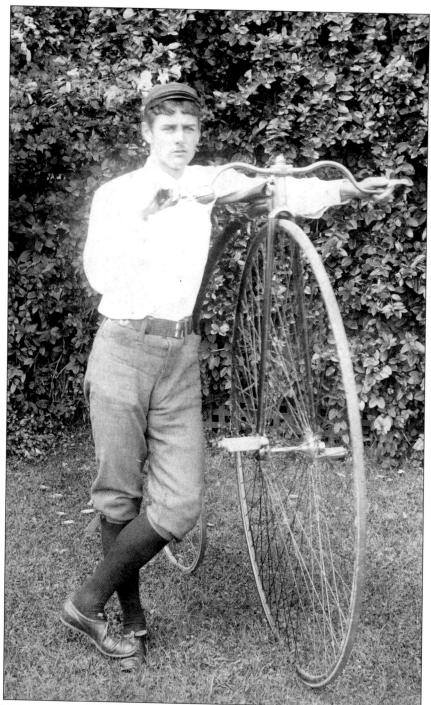

Frank M. Lyman is pictured here at age 18 with his bicycle at Woodacres on August 16, 1891. Unlike their brothers, George and Harrison Lyman, Frank and James lived into old age. After the 1916 partitioning of the Woodacres estate for the golf course, the rest of the property was redeveloped in the middle decades of the 20th century. The house survives on two acres. (Courtesy Gray Lyman.)

BIBLIOGRAPHY

Bayles, Richard Mather. *Historical and Descriptive Sketches of Suffolk County*, 1874.

Bigelow, Stephanie S. *Bellport and Brookhaven: A Saga of the Sibling Hamlets at Old Purchase South*. Bellport, NY: Bellport-Brookhaven Historical Society, 1968.

Breschard, Jayme E. *Peat Hole Pond: Historic and Natural District Inventory Form and Cultural Landscape Treatment Plan*. Brookhaven, NY: Post Morrow Foundation, 2007.

Campbell, Patricia. *Glackens in Bellport, 1911–1916*. South Country Library Archives, 2005.

Cole, Ellen, ed. *Historic Structure, Building-Structure, Historic and Natural District, and Archeological Site Inventories for East Patchogue, Medford, and North Patchogue, New York*. Cold Spring Harbor, NY: Society for the Preservation of Long Island Antiquities, 1976.

De Botton, Alain. *The Happiness of Architecture*. London: Hamish Hamilton Ltd., 2006.

Laffan, William M. *New Long Island: A Handbook of Summer Travel*. New York: Rogers and Sherwood, 1879.

McAlester, Virginia and Lee. *A Field Guide to American Houses*. New York: Alfred A. Knopf, 1984.

Principe, Victor. *Bellport Village and Brookhaven Hamlet*. Charleston, S.C.: Arcadia Publishing, 2002.

The Village of Bellport Temporary Zoning Commission. *A Planning Analysis of the Village of Bellport and Draft Environmental Impact Statement*, 1988.

Towne, Charles Hanson. *Loafing Down Long Island*. New York: the Century Company, 1921.

Volkman, Laurine T. *The East Patchogue Community and the Robinson Family*. Honor's Thesis, St. Joseph's College, June 1985.

Waterman, Virginia. "Frances H. Toms, Bellport's Mystery Lady." *The Barn Museum News*, September 2007.

ACROSS AMERICA, PEOPLE ARE DISCOVERING SOMETHING WONDERFUL. *THEIR HERITAGE.*

Arcadia Publishing is the leading local history publisher in the United States. With more than 3,000 titles in print and hundreds of new titles released every year, Arcadia has extensive specialized experience chronicling the history of communities and celebrating America's hidden stories, bringing to life the people, places, and events from the past. To discover the history of other communities across the nation, please visit:

www.arcadiapublishing.com

Customized search tools allow you to find regional history books about the town where you grew up, the cities where your friends and family live, the town where your parents met, or even that retirement spot you've been dreaming about.